Temporary
Tattoos
For Girls

D1317097

Temporary
Tattoos
For Girls

Anita Rattigan & Betsy Badwater

WITH 100 TEMPORARY TATTOOS
designed by real tattoo artists

CHARTWELL
BOOKS, INC.

This edition published in 2010 by
Chartwell Books, Inc.
A division of Book Sales, Inc.
276 Fifth Avenue Suite 206
New York, New York 10001
USA

ISBN-10: 0-7858-2658-0
ISBN-13: 978-0-7858-2658-3
QTT.TGIR

A Quintet book
Copyright © Quintet Publishing Limited

All rights reserved.

No part of this publication may be reproduced, stored in a
retrieval system, or transmitted in any form or by any means,
electronic, mechanical, photocopying, recording, or otherwise,
without the prior written permission of the copyright holder.

This book was conceived, designed, and produced by
Quintet Publishing Limited
The Old Brewery
6 Blundell Street
London N7 9BH
United Kingdom

Designer: Jane Laurie
Illustrator: Betsy Badwater
with additional illustrations by Jane Laurie
Art Director: Michael Charles
Managing Editor: Donna Gregory
Publisher: James Tavendale

Printed in China

10 9 8 7 6 5 4 3 2 1

ABOUT THE TEMPORARY TATTOOS:

Ingredients: Polypropylene, Styrene/butadiene Copolymer, Polyvinyl
Alcohol, CI 77491 (iron Oxides), CI 45410 (Red 27), CI 47005 (Yellow 10),
Acid Blue 9 (Blue 4)

Manufactured in China

Batch no: QDBCSR96299

CONTENTS

HOW TO USE THIS BOOK

Each of the top ten design categories for tattoos for young women has a dedicated chapter, and has ten original transfer tattoos designed by real tattoo artists at the back of the book.

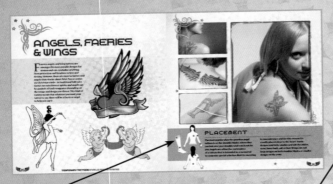

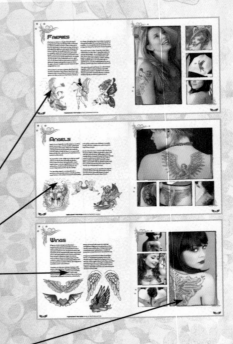

Each chapter has suggested tattoo placement ideas for the designs discussed.

Every design shown on the pages here is available as a tattoo transfer in the final 5 pages of this book.

Real photos show you how designs look on the skin.

The final 5 pages in this book are tear-out sheets of temporary tattoo transfers. There are more than a hundred designs to choose from! Simply follow the instructions opposite to get started...

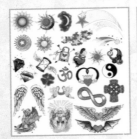
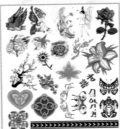
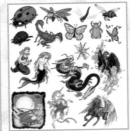
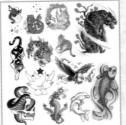
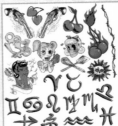

HOW TO APPLY THE
TEMPORARY TATTOOS

1 First, choose your tattoo design from the 5 tear-out pages at the back of this book, and then select the position on your body that you'd like the tattoo to be placed. **Do not use on broken or irritated skin, or on the face or neck.** Clean and dry the skin around the chosen area completely. Cut out the design of your choice and remove the transparent film.

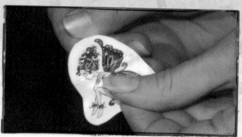

2 Place the tattoo face down on the skin. You may need to get a friend to help you out with tattoos on your back. Wet the tattoo completely with a damp cloth or sponge. Press down quite hard and evenly across the design for a few seconds.

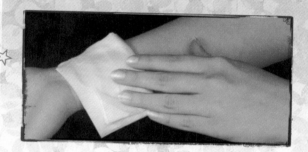

3 Peel the corner of the tattoo gently to check if it has transferred. If it hasn't completely transferred, wet again and press down. Your tattoo can last for several days if transferred carefully and looked after.

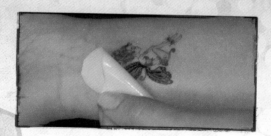

4 Your temporary tattoo will fade naturally over up to a week. To leave it in peak condition, try not to wash the area too much, and don't exfoliate. Clothes rubbing on it will also speed up its deterioration. To remove the tattoo gently, wipe with cold cream or baby oil. Rubbing alcohol will remove the tattoo instantly.

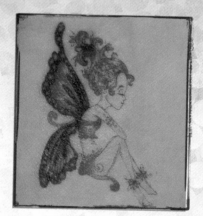

INTRODUCTION

It seems like everyone has a tattoo these days. From pop stars, singers, and actresses, to dancers, presenters and stylists, our culture is brimming with tattooed celebrities setting new trends for body art. But the practice of tattooing is nothing new. It's been used by people around the world for thousands of years, and for many different reasons—as decoration, to show membership of a tribe, devotion to a particular faith, to scare other people in battle, even as a rite of passage to mark the change from youth to adulthood. Tattoo designs, both temporary and permanent, are an art form that can cover everything from elegant and beautiful imagery to scary and powerful metaphors.

If you're considering getting a permanent tattoo (or just wonder what one might look like on you) but don't know where to start, this book can help you. Knowing what you want your tattoo to look like and symbolize is the first step toward choosing a design you'll be happy with: this book will tell you all about the most popular styles of tattoos for girls and what they mean, so you can get a feel for the kinds of tattoos that have the right look, and the right meaning, for you.

The next step is playing around with different designs and placements on your body with temporary designs until you're ready (if ever) for the real thing. Worried a tattoo will make you appear tough or unfeminine, or that your mom will go crazy? Don't be! Henna art, painted tattoos, or temporary tattoos like the ones in this book are excellent try-before-you-buy options that look just as realistic. They also come with the added bonus of zero pain and the option to erase!

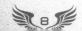

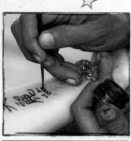

Henna

Also known as Mehndi, henna tattoos use a paste made from the leaves of the henna plant to temporarily dye the skin. Decorating with henna started in India, and is an important part of Hindu, and Muslim culture.

Airbrush Tattoos

These are painted onto the skin using a stencil, and an airbrush—they look identical to permanent tattoos, so the technique is often used in movies, fashion, and music videos.

Pen

Because ballpoint-pen ink is safe, and the designs can be so complex, tattoos drawn in pen can look almost like the real thing, and were popular in the 1990s. You can get longer-lasting, specially designed tattoo pens now too.

Temporary tattoos also help you to work out whether you're really into a particular design/image (or even having a tattoo at all) over a period of time. Better still you'll be able to gauge other people's reactions to the tattoo of your choice (you'll be amazed at the responses a tattoo can get) and measure your own boredom threshold with the design you've chosen.

Tattoos are powerful symbols and different people can take away different meanings from them. For instance, a fish tattoo might show a love of swimming to one person, but it could be a Christian symbol or the Zodiac sign Pisces to someone else. Tattoos can have many different interpretations, so it's worth being careful when choosing an image. Again, this book will guide you through the symbolism behind each and every design, so you can pick the best one for you. Read on to find out how a tattoo symbol can help you express yourself in the best and most unique of ways!

THE HISTORY OF TATTOOS

Tattoos may seem like a modern phenomenon but in reality they are a very old form of body art that has been practised throughout human history. The Egyptians, Greeks, and Romans all used tattooing techniques, as did the people of the Americas and the tribeswomen of Borneo. The word tattoo, however, is believed to have originated from the Samoan word "tatau"—the tradition of applying tatto by hand to both men and women has been unbroken in Samoa for more than two thousand years. Although tattoos have a long history, their meaning and purpose vary greatly between the past and the present.

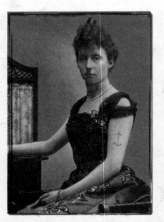
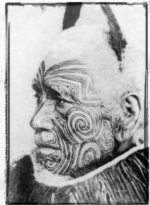
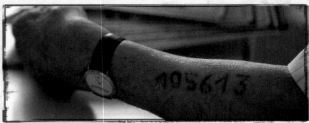

Portait of Princess Waldemar of Denmark, showing her anchor tattoo, 1907; Vintage portrait of a tattooed Maori man; A Holocaust survivor shows his Auschwitz concentration camp number.

ANCIENT PURPOSE

Tattoos have been used in the past as symbols of status and position, mostly by royalty, their heirs, or people belonging to a ruling class. These people wore tattoo symbols—like a rising sun—as a sign of their royal lineage and as a symbol of their status in society.

Depending on their religious and spiritual beliefs, followers of certain religions also had tattoos inked onto their bodies. These tattoos were either symbolic representations of their deity (like the sun or moon), religious quotes or symbols of protection. Protective tattoos were popular with warriors and travellers too, as were symbols to inspire bravery. Soldiers used to get tattoos like swords on their hands for courage, while sailors opted for tattoos of the stars to help protect and guide them at sea.

However, tattoos weren't always positive. Criminals were also tattooed in order to make them bear the burden of their crime forever in the form of public shame. Slaves were also often marked with tattoos to show ownership, so that they couldn't run away.

MODERN DAY TATTOOS

These days, people wear tattoos for many different reasons. Perhaps the most simple one is that tattoos can look great! They're also fashionable, and some people might choose a tattoo because their favourite person/celebrity has it. Emotional reasons are another prime motivation for some tattoos. People might choose images to show love for a child or parent, or as a memorial to someone they have lost (even a treasured pet!).

Religion and spirituality go hand in hand with tattoos, and many girls still get tattooed for religious or spiritual reasons. Some get the symbols of their religion—such as a star, crescent moon, or cross—while others might choose a symbol of their spirituality such as an Ohm or Infinity sign; others might even choose a quote from a holy text.

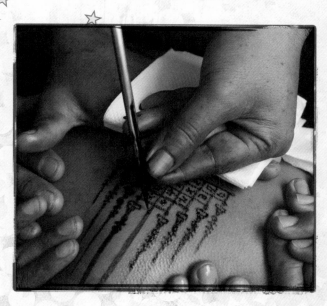

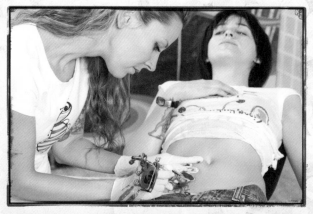

Tattoos have always been associated with tribal culture, and modern tribes are no different. Girls might get tattoos to show they belong to a certain group—it could be anything from a sports team to a part of the armed forces, or even a group of friends.

These days tattoo art embraces every style under the sun, from elaborate traditional Japanese backpieces of tigers and dragons, to modern biomech art that fuses images of the natural world with weird mechanical imagery to create cyborg-like designs. You can even get black light tattoos which only show up under UV lights. Most things you can think of—and lots of things you can't—exist as a tattoo somewhere.

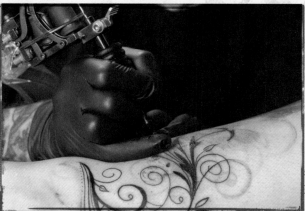

Where to wear?

Where you put your tattoo can be as important as the design itself. The main factor that dictates the placement of a tattoo is its size: large tattoos with intricate designs that need a lot of work are generally placed on the safest area of the body, like the back and the chest, or even the thigh.

Smaller designs are generally seen on the wrists and on the feet, as these areas are quite sensitive—getting a larger image would be extremely painful. On the whole, the arms, hips, and shoulders are a favourite tattoo spot for girls, mainly because these areas are easily covered up. Temporary tattoos tend to be quite small designs, and because there's no pain involved, you can put them anywhere!

Sexier imagery is often placed in more erogenous and naughty areas such as the hip, on the butt, and above the breast to add a more tantalizing edge to the design. You know it's there, but very few other people will ever get to see it!

CHOOSING YOUR ART

Where do you start? This book will give you an introduction to some of the most popular styles and designs, so use it to get a feel for the kind of thing you like. Then start looking through tattoo magazines, websites, and reference books to explore some more. Check out the work of local tattoo artists, and see if you enjoy what they're doing—if you're trusting someone with your actual skin, you want to know you like their art, after all. You'll be looking at it forever.

Of course, there's nothing wrong with walking into a tattoo studio, picking some art from the wall, and getting it done. Lots of people do. But don't forget, anything can become a tattoo—from your favourite cartoon to the Mona Lisa—so it's worth taking your time, talking to artists you like, and having them come up with something unique that's customized for you. That way your tattoo will really say something about you, whatever artwork you choose.

THINKING ABOUT INKING?

Getting something inked permanently onto your skin needs plenty of thought beforehand. There are obvious issues like cost, and potential health risks, but biggest of all is the fact that a tattoo is going to be with you for the rest of your life—so it's worth taking your time over. When you're 40, 60, or even 80 years old, will you still like that random picture of a kitten you grabbed from the internet and got inked on your foot when you were with your first boyfriend?

Our transfers are real tattoo art, the kind professional tattooists might use on their clients, which means you can use them to see if you'd be happy wearing a design forever. Put one on, and leave it for a few days: does it look good? Will you get sick of it? Where's the best place for it? You can also find out what the design you like means, and what it might say about you. A permanent tattoo is not for everyone: this book can play a small part in deciding whether or not it is for you. Either way, tattooing is a fascinating art form in its own right, and we hope you enjoy discovering more about it.

CELESTIAL

Celestial tattoos—think the sun, moon, stars and heavenly bodies such as asteroids and constellations—give the wearer the power and protection of the heavens. Each design symbolizes something slightly different: for instance, the star tattoo guides the wearer and prevents them from getting lost, while a tattoo of the sun represents a bright protecting light in even the darkest of places. On the whole, celestial tattoos are popular because they invoke the mystical idea of heavenly bodies looking over us, protecting us as we go about our daily lives.

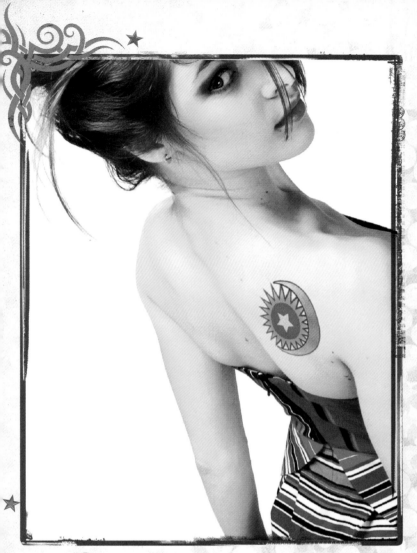

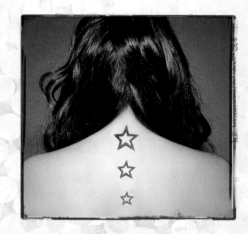

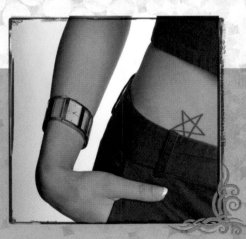

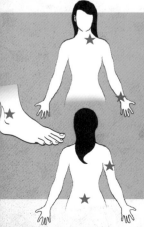

PLACEMENT

Celestial tattoos look great everywhere, because they're so simple and classic. Good locations are the arm, or between the shoulder-blades, where their shape will work well. The small of the back is another good place for the same reason. Because celestial tattoos often emphasize feminine qualities, it can be appropriate to place these designs on the clavicle, wrist, or hip.

THE SUN

The sun is our source of light, warmth and growth—no sun, no life on Earth. It's hardly surprising that the Egyptians, Greeks and Romans worshipped the sun as a life-giving force, and many cultures have revered it as a deity. The sun's cycle of rising and setting means it can also symbolize the process of reincarnation, death and rebirth. Depending on the design, sun tattoos can represent fertility, vitality, and courage, as well as personal power, leadership, and dignity.

Eagle and animal sun tattoo
In many tattoo designs the sun is represented by an eagle or alongside an eagle (but also sometimes a lion, phoenix, or even a heart, just to make things confusing), representing courage, passion, and strength.

Tribal sun designs vary from culture to culture. For the Mayans, tribal sun tattoos were the mark of leadership, depending on the size of the design and the colors used to produce the tattoo. In other cultures, tribal sun tattoos were often designed as a dark orb surrounded by warm rays beaming out across the wearer's skin, symbolizing protection and wellbeing.

The sun is often seen as a masculine symbol, while the moon is generally seen as more feminine. By putting the two together girls can create a design that represents a blending of the two forces, with the masculine and feminine aspects existing in harmony (if only it was always that simple).

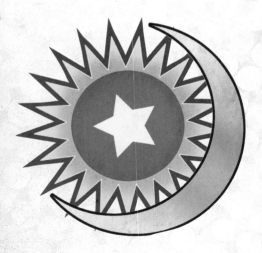

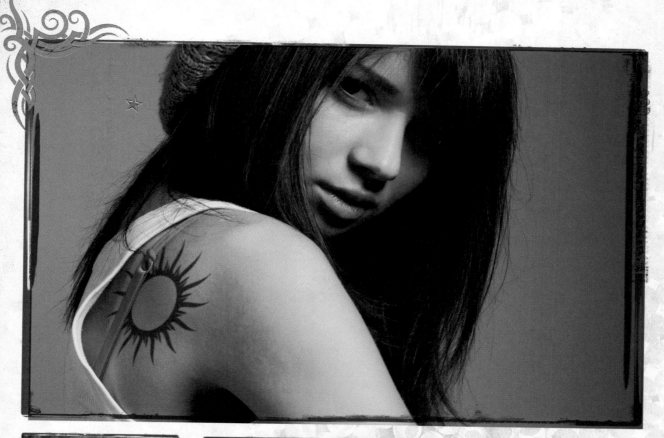

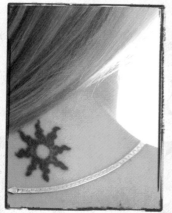

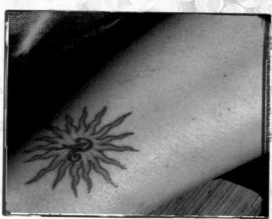

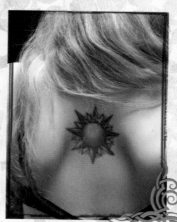

STARS

Star tattoos can be simple symbols of light, truth, and hope in darkness. However, there are many other potential meanings depending on the exact design you choose, all of which will let you personalize your star tattoo and really allow it to say something about you.

In Celtic lore the pentagram (a five-pointed star) was the sign of storytellers and magicians, its five points symbolizing protection and balance in the world. Be warned, though! If your pentagram points downward, it's thought to be a sign of the devil.

Also known as the Star of David, the Hexagram (a six-pointed star) is a powerful symbol of Jewish identity and has strong links with Kabbalah (Jewish mysticism); it's also known as the Seal of Solomon.

The Septogram (a seven pointed star) is a mystical symbol due to its links with the number seven (which is seen as lucky in some cultures) and classical astrology.

Nautical stars were navigational tools used by sailors to get them home safely, so as tattoos they become symbols of protection and guidance, helping you navigate the seas of life. In some cultures the nautical star is also the sign for bisexuality, but be careful which sailors you mention that to.

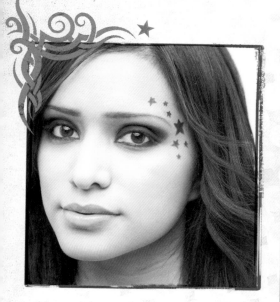

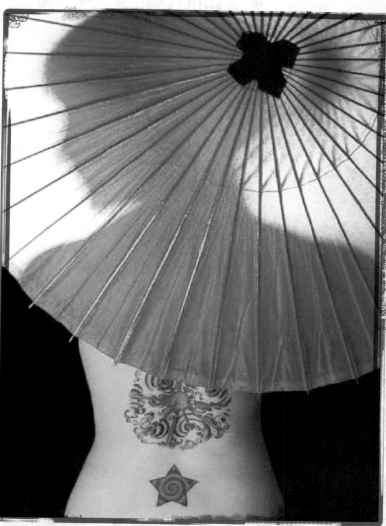

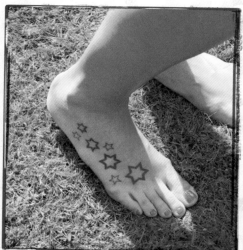

SHOOTING STARS

Traditionally shooting stars symbolize change or the wish for a better life, which is why these tattoos are associated with an important moment in time—such as a romance or an event that may have changed the wearer's life. Shooting stars also represent reaching your ultimate destiny, which is why some girls get them to represent ambition and the inner desire to be a star.

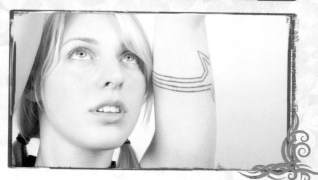

The Moon

The moon is often seen as a potent feminine force, linked to the emotions, motherhood, and nurturing. In fact, before Sun worship a large number of cultures worshipped the moon and believed it to be the supreme deity, which controlled the cycle of life. As a tattoo it can take on many forms such as the crescent moon, harvest moon, or a blue moon, all which have individual meanings.

Because the moon is universally associated with water and tides it's often viewed as a uniquely feminine symbol, linked to the female cycles of menstruation. While female moon tattoos can have different interpretations, many are related to elements of caring and nurturing.

The crescent moon and star is an internationally recognized symbol of the faith of Islam and is featured on the flags of several Muslim countries (though many Muslims reject using the crescent moon as a symbol as the faith of Islam has traditionally had no symbol). Historically, the crescent moon and star symbol were used by the peoples of Central Asia in their worship of sun, moon, and sky gods.

A blue moon is a second full moon in a calendar month. It's an uncommon occurrence (it only happens every few years), so the blue moon is seen as something special and symbolizes rarity.

The Harvest Moon is the full moon that occurs nearest the equinox on September 23 in the northern hemisphere and March 21 in the southern hemisphere. This moon is a symbol of fertility, wealth, and prosperity as it's often closely linked to the harvest, which brings food to all.

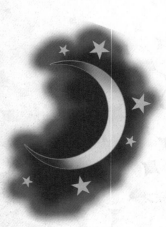

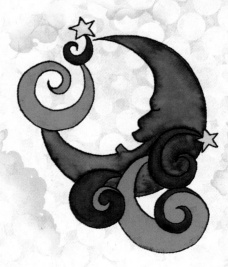

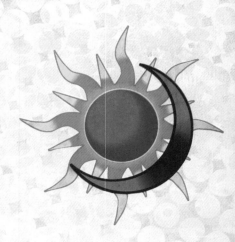

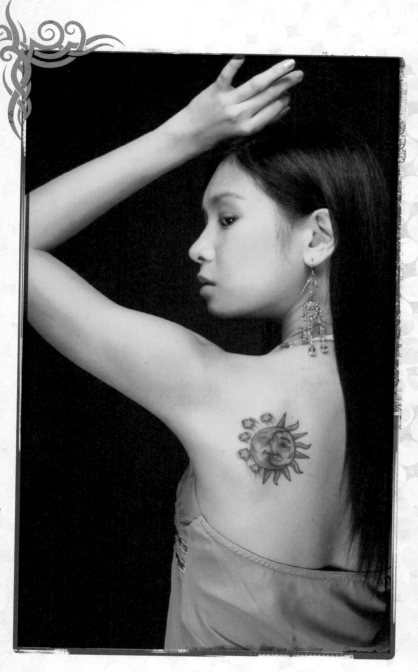

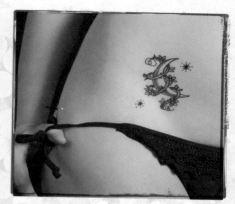

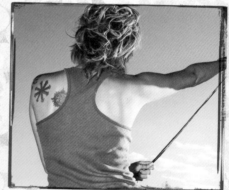

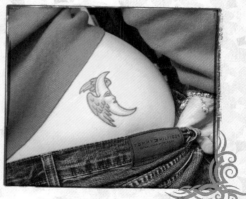

SYMBOLS

Symbols such as cave paintings and carvings were man's earliest forms of communication, recording our history and beliefs long before we created a written language. Even today a symbol can tell another person a world of information about you, such as your faith, or heritage. Don't forget that symbols can carry more than one meaning, too—the swastika is an ancient Hindu symbol, for example, but because it's so closely associated with Nazi Germany very few people choose one as a tattoo. Pick your symbol with care!

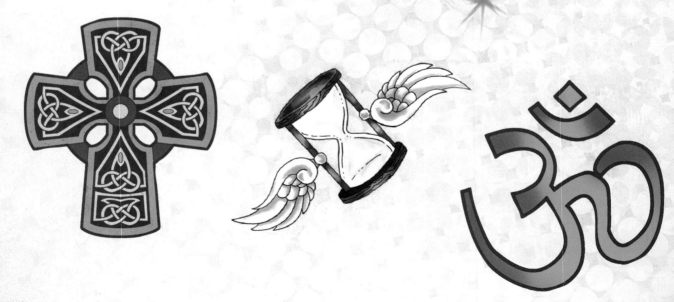

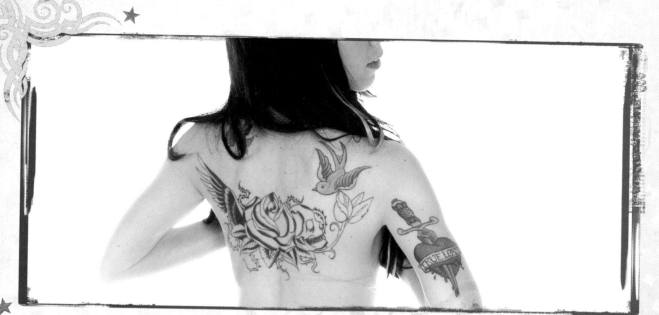

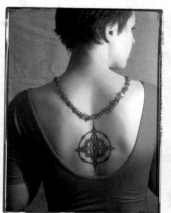

PLACEMENT

Symbol tattoos can make a statement on their own, or can be subtly placed within a bigger design on the shoulder or back. Often, symbol tattoos are designed to remind the wearer daily of their faith, and as such are best placed on a frequently-viewed point such as the ankle, wrist, or hand.

Traditional Symbols

Traditional symbols are often linked to religions and are a good way for girls to show their faith; they can also symbolize spiritual or philosophical ideas such as infinity and harmony.

The Yin and Yang tattoo is called Taijitu in Chinese and is a Taoist symbol. Yin is the black part: female, passive, night, water, and earth. Yang is the white part: male, active, day, fire, and air. The combination of Yin and Yang symbolizes balance and harmony—no black without white, no white without black.

The Om (or Aum) sign is the main symbol of Hinduism. It is a sacred syllable representing the Absolute—the source of all existence—and is used to signify divinity and authority.

Looking like a number eight lying on its side, the infinity symbol represents something which is limitless and without boundary or end. Along with circles and loops, it symbolizes the idea that life is eternal, and cyclical, always moving from birth, to death, to rebirth.

The most popular cross is the Latin cross, which is a Christian religious symbol. However, cross tattoos are more ancient than you might think and are not always religious—for example, the pagans used crosses as phallic symbols and to represent the moon.

The Ankh cross symbol is an Egyptian symbol, which predates Christianity and symbolizes the union between the gods Isis and Osiris. Girls might wear one for magical protection, or to show a belief in eternal life.

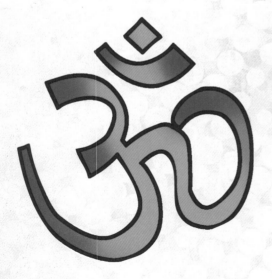

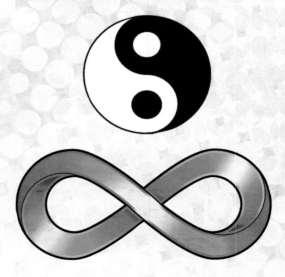

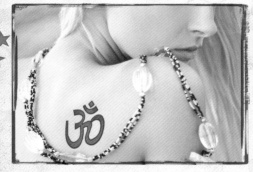

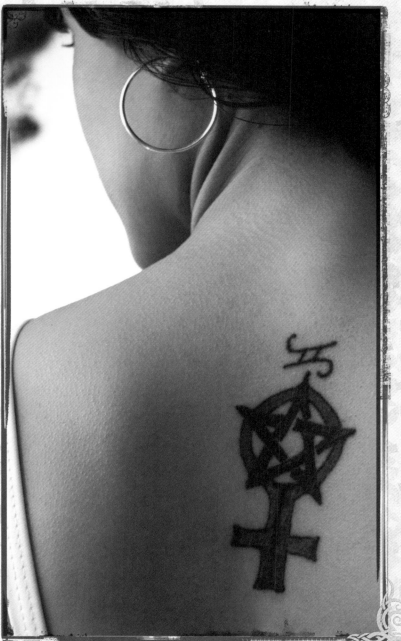

Irish Symbols

Irish symbols are increasingly popular these days, but they carry a range of different meanings—so you don't have to be of Irish descent to pick one as a tattoo!

Also known as the Irish cross, this is a standard Christian cross with a circle around the upper part of the cross and intricate knot-work across the main body of the cross. Legend has it that the cross was used by Saint Patrick (the patron Saint of Ireland), when he was trying to convert the pagan Irish people to Christianity. The cross is a combination of the Christian cross and the sun that was worshipped by the pagans.

The Celtic shamrock may look like the four-leaved clover (a symbol of luck) but this triple spiral of Celtic knot work is the symbol for the holy trinity of the Irish Catholic Church. The first leaf stands for hope, the second for faith, the third for love, and the fourth for luck.

The classic clover design has a dual function: it can be a proud sign of Irish heritage, but also a powerful symbol of good luck (so you don't need to be of Irish descent to get one).

The triquetra are three interlocking pieces in a triangle form. In Christian Ireland and other areas, the triquetra was used to represent the Holy Trinity, but the symbol itself far predates Christianity and is a Celtic symbol of feminine spirituality. In some modern traditions, it represents the connection of mind, body, and soul, and in Celtic-based Pagan groups it is symbolic of the three realms of earth, sea, and sky.

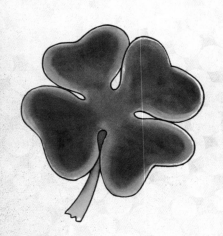

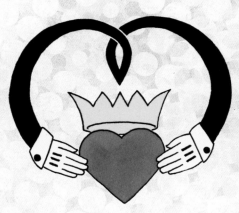

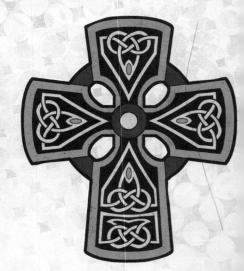

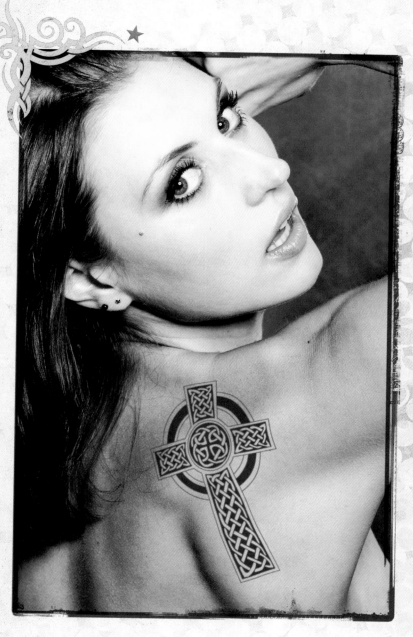
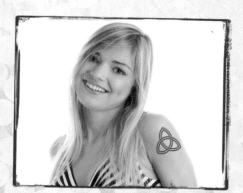
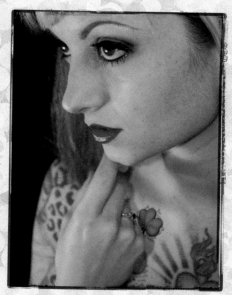
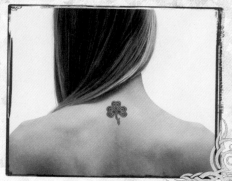

Modern Symbols

Although the majority of modern symbols have their roots in the ancient world, their meanings have evolved over time so they can speak to people in the twenty-first century. The heart is best known as a symbol of love, of course, but it can mean other things as well:

There are hundreds of variations of hearts, such as a heart surrounded by thorns (a Christian symbol), a heart pierced by an arrow (cupid, or showing that the wearer is in love), and the Heart with Wings Tattoos (showing that the wearer is a free spirit).

The lock and key play a significant part in folklore and are symbols of magic and power. Lost or found keys were a favorite theme standing for both liberation and imprisonment. A key can also symbolize the transition from one phase of life to another. In some cultures young people are given a "key to the door" when they reach 21, to show that they now have access to the adult world.

The hourglass conjures up the notion of time passing, and the inevitability of death. The addition of wings represents the idea that time flies and life is precious.

Gemstones hold a variety of meanings and properties and can be chosen according to your birthstone, or simply because you like the way they look. Popular gemstone tattoos and meanings:
Ruby—a symbol of friendship and love and also the symbol of vitality and royalty.
Moonstone—brings good fortune, enhances intuition, and brings success in love.
Amethyst—symbolizes piety, humility, sincerity, and spiritual wisdom.
Jade—an ancient stone that has historically been used to attract love.

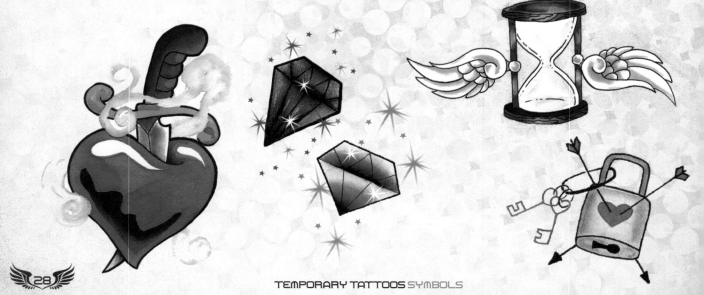

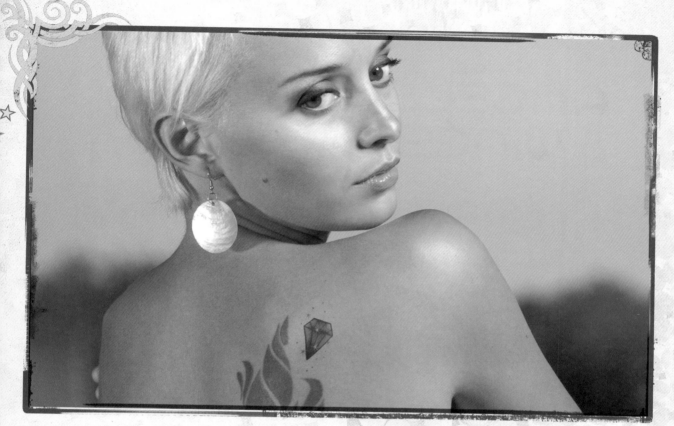

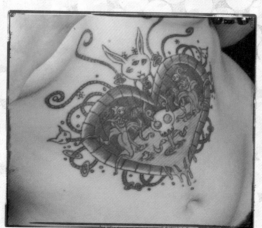

ANGELS, FAERIES & WINGS

F aeries, angels, and wing tattoos are amongst the most popular designs for women and can symbolize anything from protection and freedom, to love and destiny. However, there are more to faeries and angels than stories about Peter Pan or scenes on Christmas cards—in traditional folk tales faeries are mischievous spirits, and angels can be symbols of God's vengeance depending on the image and design you choose. This kind of variety means that whatever you want your tattoo to say, there will be a faerie or angel to help you say it.

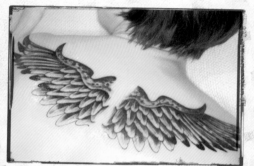

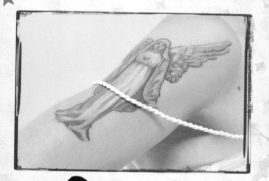

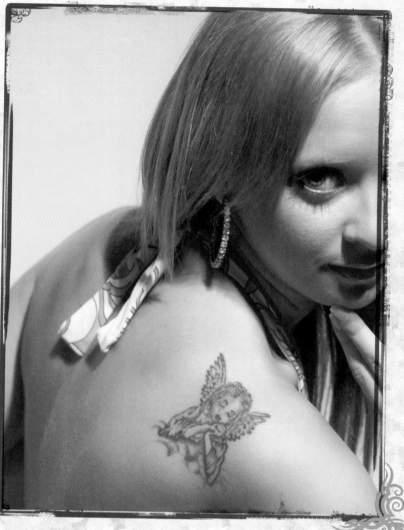

PLACEMENT

The most popular place for guardian angel tattoos is on the shoulder blades, where they can look over your shoulder and watch out for you. Angels are often the centerpiece of a tattoo that is intended as a memorial to someone special who has died. Its meaning is remembrance and for this reason it's usually placed close to the heart. Faerie designs tend to be smaller, and suit the ankles, wrist, lower back, calf, or foot. Wings can suit large designs on both shoulder blades, or smaller designs on the arms.

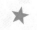

FAERIES

The faerie or fairy is a magical female figure originating in Celtic mythology. Often depicted as small, beautiful creatures with wings and a human appearance, they have a range of powers including the ability to cast spells, influence the future, and fly. The traditional faerie (or fairy) is a naughty spirit who can bestow gifts upon people such as beauty, wealth, and kindness, but also perform petty and harmful tricks on people she doesn't like (even Tinkerbell was no saint). As a result faerie tattoos can mean a wealth of different things, making them a great choice for girls who are troublesome one moment and delightful the next.

Flower faeries are tiny creatures that live in the bottom of gardens. Each flower faerie lives and sleeps in their chosen flower or tree, and as this grows the fairy grows too. Each flower faerie is in charge of looking after their plant; keeping it strong and healthy by ensuring it has plenty of sunshine. As a result this faerie symbolizes love, caring, the natural world, and a nurturing spirit.

The word "faerie" comes from the Latin "fata," which refers to the Fates—guardian spirits in ancient mythology—so it's hardly surprising that faerie have been used in literature and myth to explain the workings of fate and the trials of childhood as we move through to adulthood. As a result traditional faeries are a potent symbol of destiny, childhood, and youth.

The natural world and fairies are often linked together, with tree faeries being especially popular. These tattoos can have vines, leaves, flowers, and other natural elements to them reinforcing the symbol of a nature spirit.

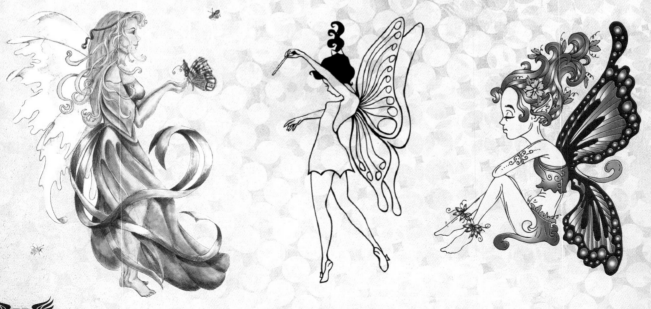

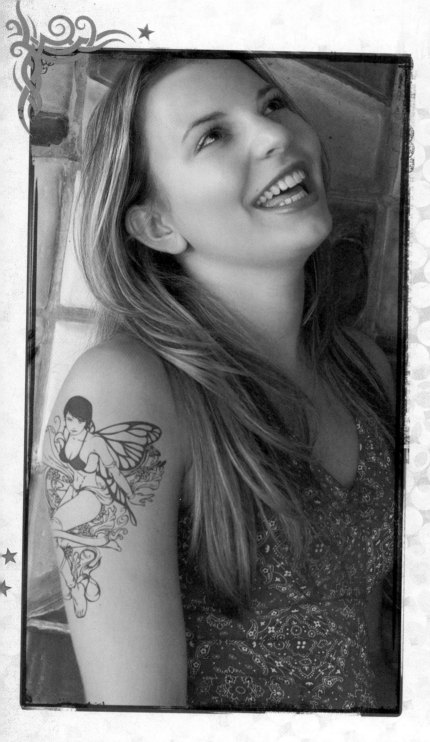
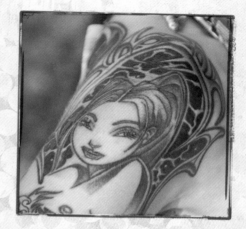
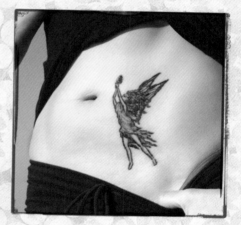
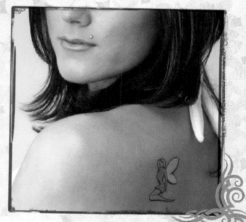

Angels

Angels were originally overtly religious symbols, divine messengers of God, usually symbolized in male form with wings. They were regarded as being much more powerful than humans and throughout biblical times it was generally believed that the will of God or "God's Work" was carried out by angels.

You don't have to be religious to want an angel tattoo, as angels now generally symbolize protection, devotion, and spirituality. Some angel tattoos can also signify innocence, love, and purity, or hold special meaning for the wearer depending on the specific design.

The guardian angel is considered to be a protector of humanity, and as a result guardian angel tattoos often depict human forms holding or keeping a watch over children. Generally, people who love children or seek protection wear these tattoos.

Lucifer (also known as Satan or the devil) was the first angel to fall from paradise when God cast him out of heaven; fallen angel tattoos usually depict a beautiful angel holding a bloody sword or with torn or injured wings. These tattoos tend to be popular amongst Goths, bikers, and people with an affinity to the dark arts, or with anyone who feels that they are outside of conventional society.

Cherub angels tend to be chubby and playful and are considered to be messengers of love; cherub tattoos generally depict an angel shooting an arrow or piercing a heart.

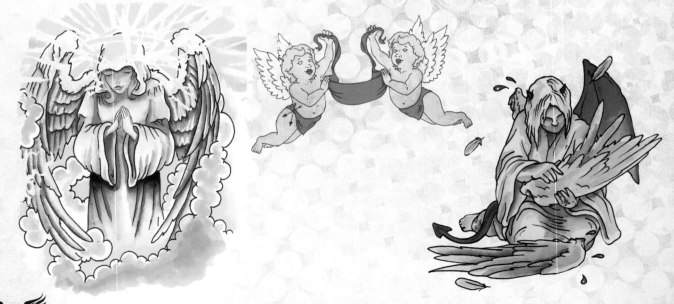

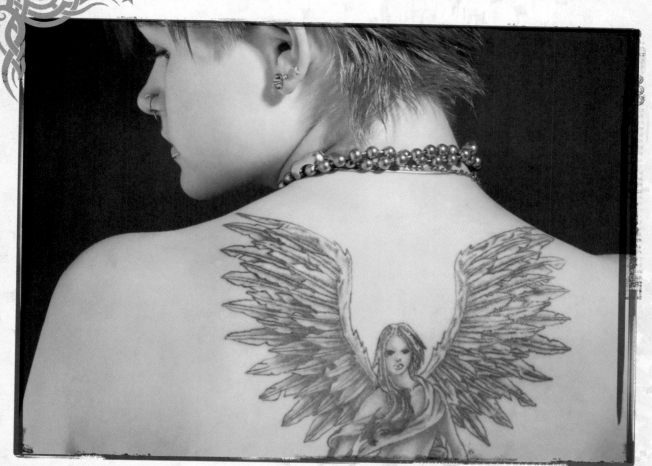

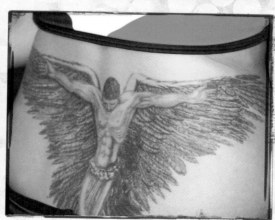

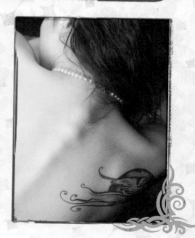

WINGS

Wings as a tattoo design can often have inspirational or spiritual symbolism. In many myths, wings have to be earned by their wearer and represent hard work, elevation, freedom, and aspiration. In the ancient world, wings represented power and speed, which is why statues and images from ancient civilizations depict an animal, such as a lion or horse, sporting wings. Over the centuries, many of the ancient wing symbols were incorporated into modern cultures and religions to symbolize power and swiftness.

Gargoyles are fearsome-looking creatures with horns, a tail, and talons. They guard buildings like cathedrals and churches, driving away evil spirits with their appearance. Gargoyle–faerie wing tattoos act as talismans to protect the wearer from evil, just like a gargoyle perched on a church spire.

Wings associated with angels are spiritual, symbolizing enlightenment and guidance; they can also represent the idea of being "taken under something's wing," making them a symbol of protection to keep the wearer out of harm's way.

Wings associated with butterflies, dragonflies, faeries, or mythological winged creatures like dragons and the winged-horse Pegasus, have an element of the magical about them. They symbolize transformation, like a caterpillar emerging from its cocoon with new wings, and also the wearer's ability to "take flight" and move on, overcoming any obstacles in their path.

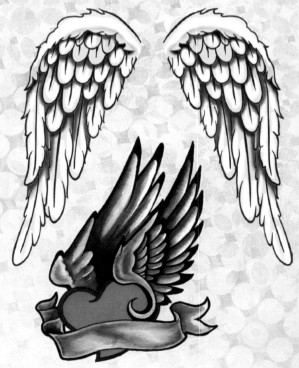

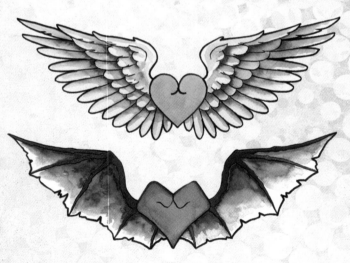

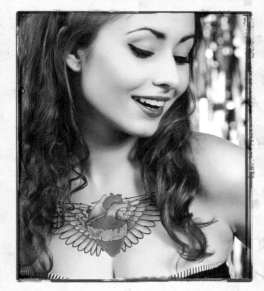
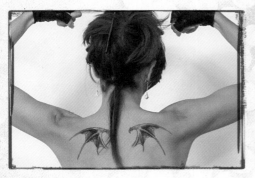
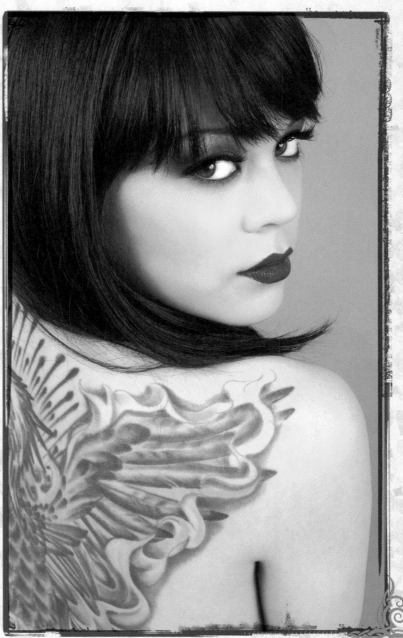

FLOWERS

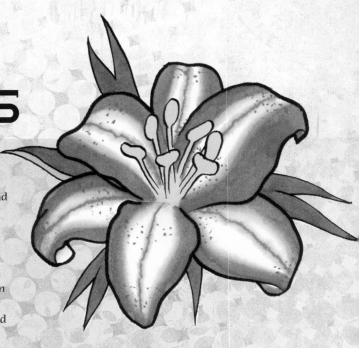

Like their real-life namesakes, there's a flower tattoo for every occasion. They can make us think of beauty, purity, nature, and life, with various flowers symbolizing everything from birth and love to strength and loss. Flowers are a powerful visual reminder of the process of life, because we see them growing, blooming, drying up, wilting away, and then being reborn as a new flower. Different flowers also hold their own meanings and myths; even the color of the flower you choose can represent something different and symbolic. The only real difference is that these ones can't make you sneeze...

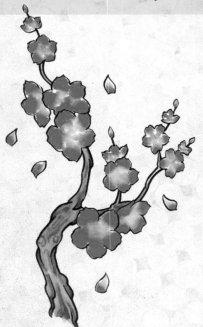

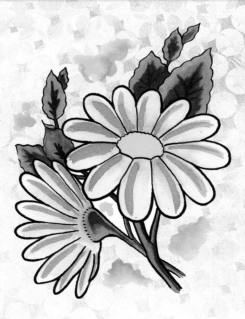

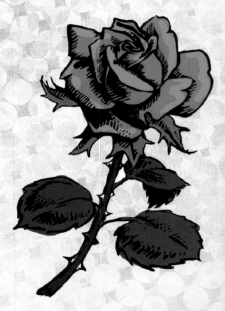

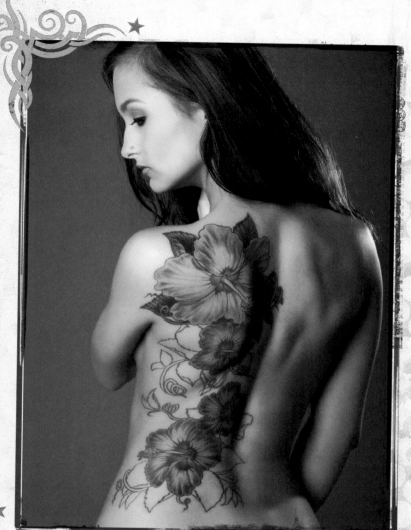

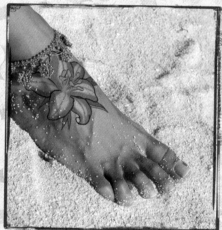

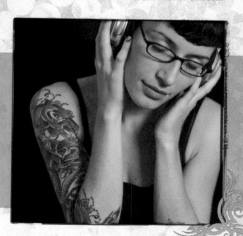

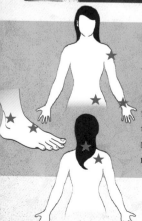

PLACEMENT

Flower tattoos have a very wide range of design and meanings, and can be placed pretty much anywhere—from the wrist, arm, ankle, hip, shoulder, nape of neck, to the legs, foot, and lower stomach. Elaborate and detailed flower designs suit the larger expanses of skin on the rib, arm, shoulder, and back.

Roses & Lotus Flowers

The rose is the most popular of the flower tattoos and can be seen in various forms from a rose with a heart to a rose with thorns. In general being tattooed with a rose symbolizes love, or more specifically a pure love and passion for another person. Much of its symbolism has to do with the red rose being a flower that is given on romantic occasions.

For all its potential beauty, love is never without risk. A tattoo of a rose with thorns reminds us that love can hurt sometimes, and that happiness does not come without its share of hard times: if you're willing to grasp the rose of love, you must also be prepared for the prick of the thorns. The color of the rose you choose also holds special meaning: Red roses are for romantic love (and also the blood of Christ or the Virgin Mary for some Christians). Yellow roses are for friendship. White roses represent purity and true love. Orange roses represent a new beginning. Pink roses symbolize happiness and thankfulness. Blue roses only exist in fantasy not nature, so they represent the impossible and unattainable. Black roses symbolize rebirth.

There is a good deal of mythology around the lotus flower and it's sometimes seen as a symbol of creation. Egyptian myth has the sun emerging from the newly opened petals of the flower, while in Hinduism the goddess of wealth and prosperity, Lakshmi, is pictured sitting on a lotus flower—a sign of her purity. In Buddhism, Buddha is said to have risen at the center of the lotus blossom. Many cultures also use the lotus as a sacred symbol representing freedom from the material world; as a tattoo it can symbolize love, beauty, goodness, fortune, enlightenment, and peace.

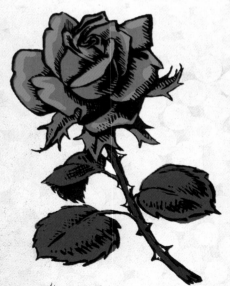

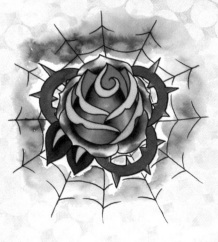

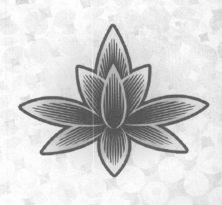

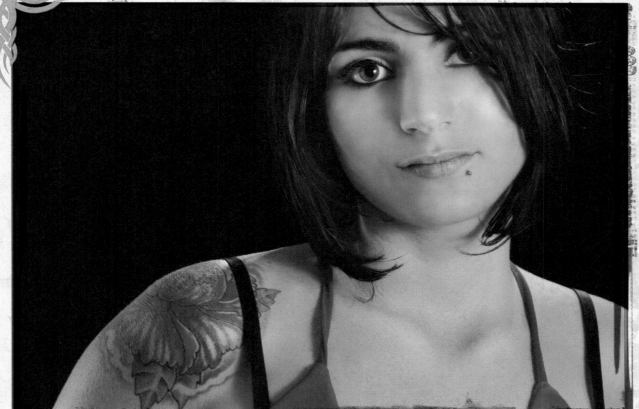
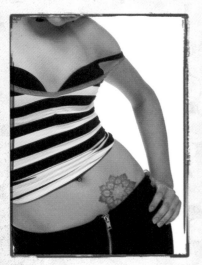
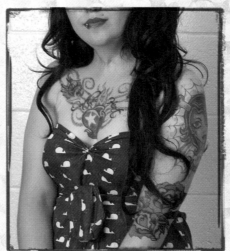
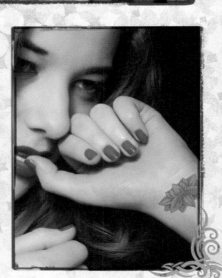

Cherry Blossom & Lilies

The cherry blossom season only lasts for about two weeks a year, so it says something about the beauty and enduring appeal of these little blooms that they should have such deep meaning in Chinese and Japanese culture (although what they mean is quite different in each place). You only need to see cherry blossom once to remember it forever, which is maybe why it makes for such a strong tattoo design.

For the Chinese the cherry blossom is a very significant symbol of power. Typically the blooms represent feminine beauty and sexuality, often containing ideas of power or feminine dominance. For the Japanese the cherry blossom season is very important as it represents the transient nature of life, blooming and fading as quickly as the flowers. This concept ties in with the teachings of Buddhism, which state that all life is suffering and that all things must pass. Bushido, the

samurai's code, also takes the cherry blossom tattoo as its emblem as it signifies the perfect death for a true warrior, who has lived with constant awareness and acceptance of the precariousness and fragile nature of life.

Lilies have long represented purity, innocence and remembrance, but they also denote erotic love and fertility, which makes them one of the most ambiguous flower designs. Due to their association with Christianity, lilies are also associated with the newly departed soul, which is why they can also be used as memorial tattoos. To the Chinese, the lily flower is used to symbolize summer and abundance, while the Romans linked the lily to the Goddess of love, Venus. As you can imagine, the vast array of lilies means that tattoos can say many things. For instance, the Calla lily is a symbol of beauty, while an orange lily stands for hatred; and the tiger lily tattoo stands for pride or prosperity.

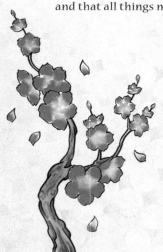

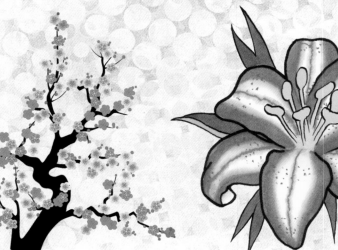

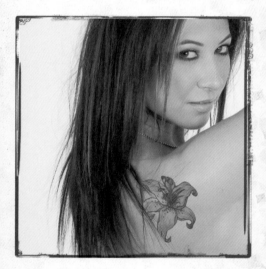

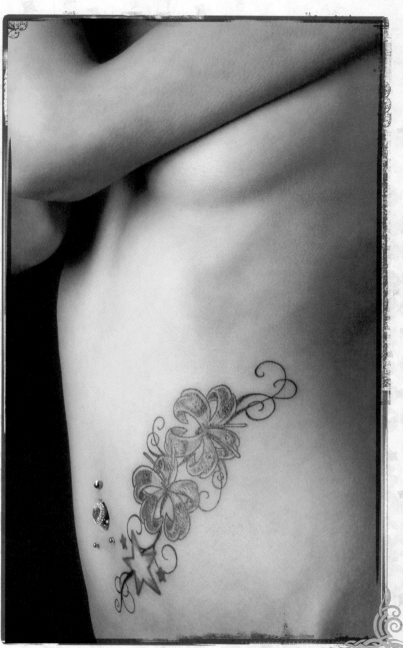

Orchids, Daisies & Wildflowers

Orchids have both masculine and feminine meanings. On the masculine side they tend to denote sexuality (that's boys for you), while on the feminine side, the orchid symbolizes beauty, charm, and refinement. The orchid is also considered a love potion and aphrodisiac in many countries, including Egypt, Germany, China, and Africa. However, the orchid is also a symbol of wealth, due to the fact that in the late 1800s they were so highly sought after that they became known as a symbol of luxury and rare beauty.

Daises symbolize perennial beauty usually due to the fact they can be found in abundance in the spring and summer time. They are also linked to Christianity due to the use of the daisy with the image of the Virgin Mary and baby Jesus. For this reason and the fact that old Celtic lore associates them with children who have died, daisies are also associated with innocence and childhood.

Wildflowers are literally flowers that grow wild and are not specifically grown from seeds and cultivated, and for this reason they can have a myriad of meanings from freedom, autonomy and independence, to joy and happiness. Depending on the design, color, and variety of the flower, a wildflower tattoo can also symbolize healing properties and good health.

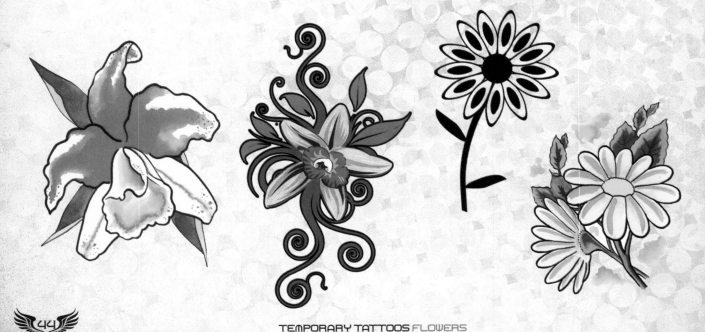

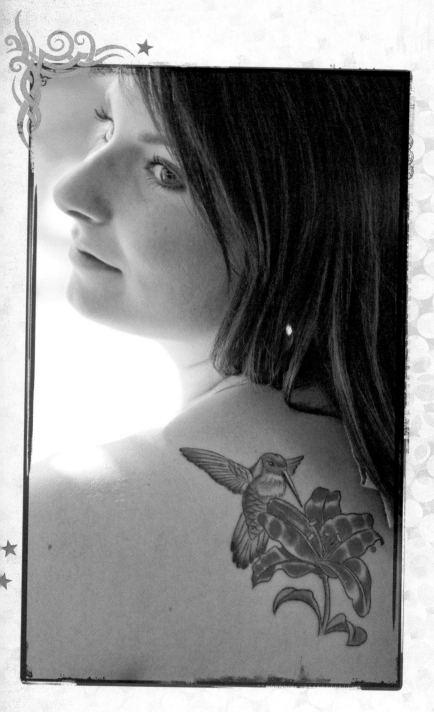
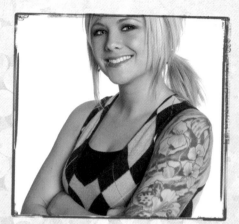

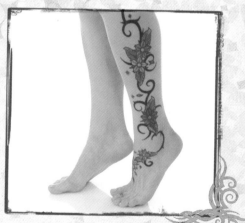

TRIBAL & DESIGN

Tribal tattoos are one of the most popular styles in the world, made up of bold black lines that really catch the eye and look great all over the body (although they're most commonly worn around the arms, shoulders and back). Tribal tattoos can simply make the wearer look and feel stronger but they can also reinforce positive feelings, or express spiritual, magical, or religious beliefs and convictions. Because tribal tattoos are so deeply rooted in the heritage of ancient communities from all over the world they can have many layers of meaning—so it pays to research your design carefully, to make sure it's the right one for you. The same is true of exotic tattoos, such as those using Chinese characters, Japanese kanji symbols or Arabic script—it's easy for messages to get lost in translation, so make sure you double check your design if you're thinking about a permanent tattoo (don't worry, we've checked all our tattoos for you).

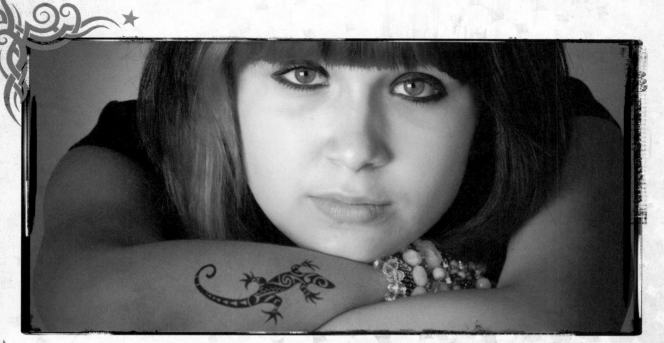

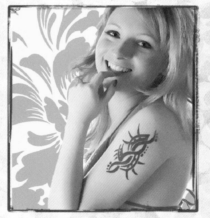

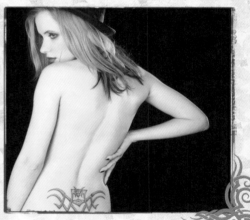

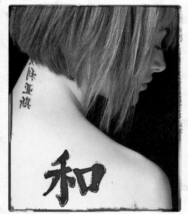

PLACEMENT

Tribal tattoos are big, bold, and designed to catch everyone's attention or tell a story about your life. They're usually worn on the upper arms, chest, and back so that they're easy to display, but traditionally women had them all over their bodies, so feel free to try them out wherever you like! Forearms, legs, and even hands can work as sites for your tribal tattoo.

Polynesian & Modern Tribal

The tribal style of tattooing has its roots in the Polynesian Islands. Tattoos here were often used as a form of non-verbal communication to symbolize many things, including social belonging, courage, tribal status, genealogy, and religious beliefs. Intricate, bold, linear, and geometric, Polynesian tattoos were traditionally placed on the back (and not on the arms, unlike contemporary armband designs). Often large, and denoting social status and rank, the tattoos were done with a shark's tooth. Not enduring the whole process was considered to be a source of shame. (Another reason to be thankful for temporary tattoos!)

On Tahiti women were tattooed for a different reason, with many young girls getting their first tattoo as young as seven years old and again when they reached sexual maturity. Later when they wanted to charm a man they liked, they would show their tattoos as a sign of interest.

The distinctive style of modern tribal tattoos, with lots of sharp edges and bold black designs, has evolved from all the Polynesian (and also New Zealand Maori) styles. They combine the traditional meanings associated with tribal art with a huge range of images. Depending on what the wearer chooses, you might see strong geometric patterns, animals, or even mythical creatures drawn in a tribal style. The modern tribal style can be a bit masculine though, and lots of tattoo artists are now softening up their designs with modern design serifs. Some members of sports teams, bands, or groups of friends—all tribes in a way—might get the same design to share a sense of belonging.

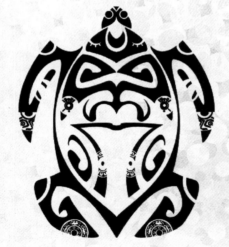

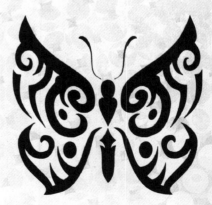

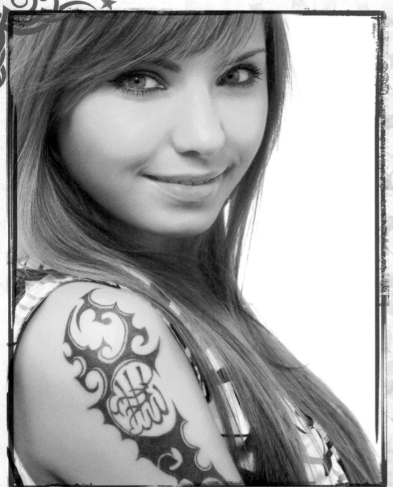

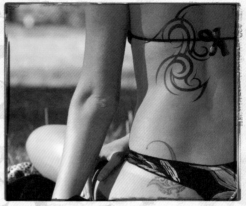

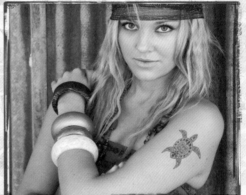

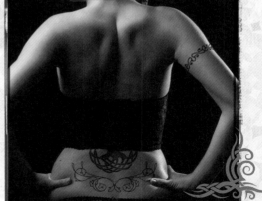

POPULAR DESIGNS

Popular Polynesian Tattoos include geckos who are believed to have supernatural powers, and are therefore feared. Polynesian statues called Tikis made most commonly of wood represent human figures. Turtles are symbols of fertility and longevity and shells are symbols of wealth.

Celtic

The Celts were a group of Indo-European people whose history goes back to the second century BCE. Though loosely united by a similar language and religion, they were not centrally governed and quite happy to fight each other's tribes. Celtic art springs from all of these conflicting cultures and holds various meanings but its style is primarily ornamental, often involving knot work, spirals, key patterns, lettering, plant forms, and animal figures.

The Claddagh tattoo is one of the most popular of the Irish Celtic tattoos and depicts a heart with a crown, held by two hands. The heart stands for eternal love, the hands for friendship, and the crown for loyalty. It's usually used as a love token or wedding symbol.

This mystic Celtic knot—also known as the endless knot—symbolizes eternity, as the lines of the knot form an infinite loop with no beginning or end. The most popular of the Celtic knots is the Celtic trinity, a triangular knot with three corners signifying various things depending on your beliefs, i.e. Christian (Father, Son, and Holy Spirit); New Age (Mind, body, and spirit); or Pagan (mother, Crone, and Maiden).

Also known as love knot tattoos, Celtic heart designs symbolize the union of souls and are often chosen by girls who want to express their devotion to loved ones. These are very similar in construction to normal knot work but incorporate animal heads, legs, tails, bodies, or feet into the designs.

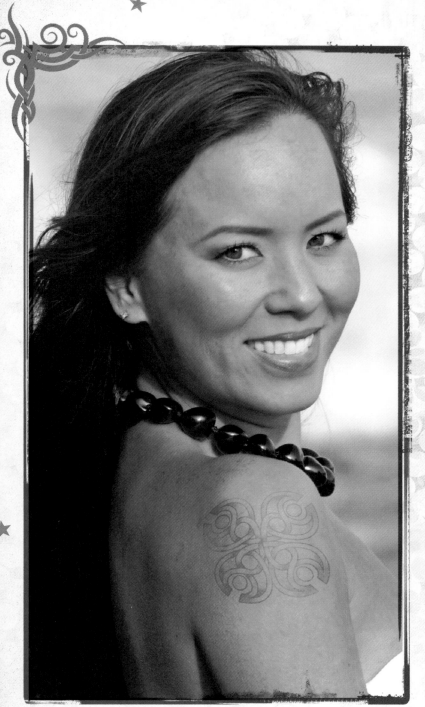
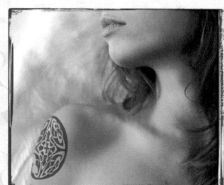
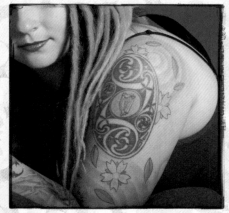
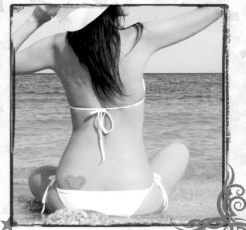

Chinese, Arabic & Aztec

Tattoos were seen as a negative thing in traditional Chinese and Arabic culture due to the belief the body was sacred and shouldn't be altered in any permanent way. However, they are popular in the West—although as always it pays to check the translation from a reliable source before choosing a design. There's nothing more negative than accidentally having the word for "idiot" (or worse) tattooed on your body, after all.

In mainstream Chinese culture, the first tattoos were considered a punishment and were only branded on criminals, which is why tattoos are still felt to be a sign of the criminal world. However, in the West, popular Chinese character tattoos are the symbols for strength, peace, hope, courage, and the symbol for Zen. Other popular Far Eastern designs include the Chinese dragon, a benevolent creature that symbolizes luck, fertility and happiness; and the tiger, which symbolizes hope, vanity, courage, and self-reliance.

Another very popular choice for tattoos in the West is Kanji, one of the three forms of Japanese writing. It's worth bearing a couple of things in mind if you're considering a Kanji symbol: they mean very different things to Chinese symbols, and they're only popular in the West and not in Japan (where there is still a lingering association with yakuza gangsters), although this thinking is changing.

Because tattooing is not a common practice in the Arab world, there is very little original source material—so Arabic tattoos are mostly words, names, phrases, and scripture that have been translated into Arabic from other languages. The Hand of Fatima (the fifth and favourite daughter of Mohammad) is also a popular Arabic tattoo and is sometimes known as the khamsa hand, a five-fingered hand that is thought to bring good fortune and to ward off the evil eye.

Pure

Harmony

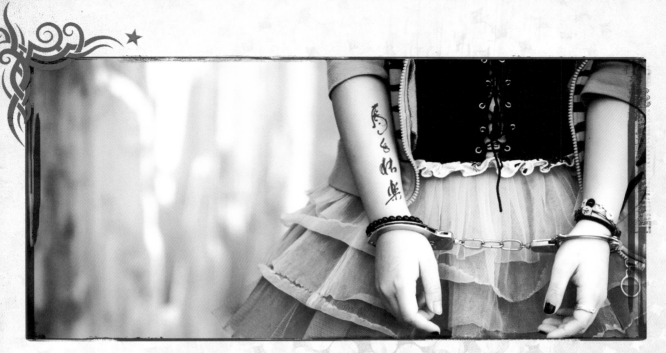

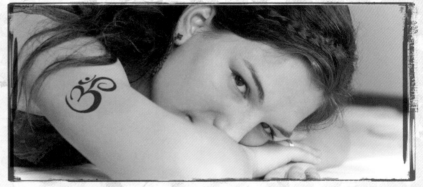

ANCIENT AZTECS

The Aztec civilization was one of the most advanced of all the ancient cultures, which is why Aztec art and tattoo art is highly developed and intricate. As the Aztecs used the art of tattooing as part of a religious ritual many of their designs revolved around the theme of the Sun, who was their principal deity. Other very popular themes in Aztec art are Eagles, Warriors, Princesses, and The Aztec Calendar Wheel (also known as the Sun Stone).

BUTTERFLIES & INSECTS

There are more than 800,000 known species of insects, which is why butterflies, insects, and creepy crawlies have always featured in the sacred history of many cultures. While many insects—such as the butterfly and dragonfly—are associated with beauty, love, and metamorphosis, others have a darker and more malevolent meaning, with certain beetles and moths being associated with the underworld and even death.

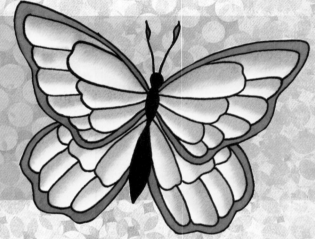

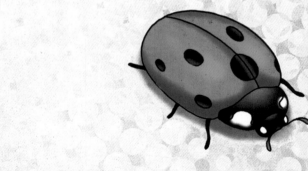

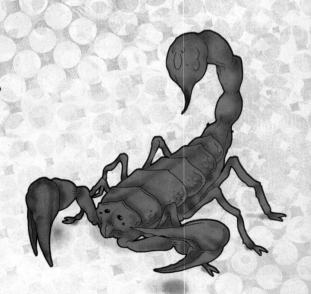

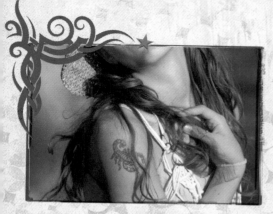

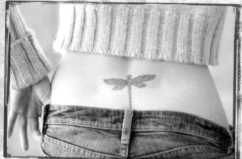

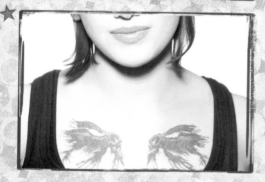

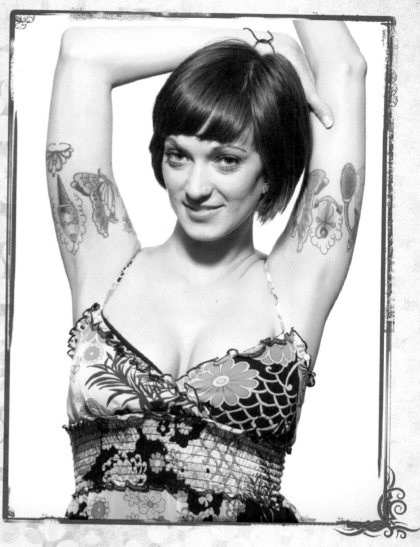

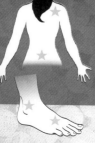

PLACEMENT

Everywhere! Insects can crawl up your leg, sit on your foot, march up over your shoulder, hide in your armpit (if you must), perch on your shoulder...you name it. Placement of insect tattoos can be funny, like a column of ants trundling up your leg, or more serious, like a precious butterfly on your hip or a scarab over your heart for protection.

BUTTERFLIES & DRAGONLIES

The single most popular tattoo design for girls is the butterfly. Known for its beauty and short lifespan, the butterfly in general signifies regeneration and flight. However, its meaning also varies from culture to culture.

In Japan, one butterfly stands for young womanhood while two symbolize marital bliss. To the Aztecs of ancient Mexico however, the butterfly represented both the souls of dead warriors who had fallen on the battlefield and the souls of women who had died in childbirth—the two most noble deaths possible for an Aztec.

In the West, the symbolism of the butterfly centers upon its unique transformation from crawling caterpillar to winged creature, making the beauty and metamorphosis of the butterfly one of its most powerful and uplifting meanings.

Dragonflies are the second most common tattoo for girls, with many cultures (especially in Asia) seeing the dragonfly as a symbol of joy and happiness, as well as courage and strength.

In the West dragonflies are a symbol of rebirth or renewal after a great hardship or loss. But mostly, a dragonfly signifies transformation because it begins its life in water and then changes into a flying creature when it matures. For this reason a dragonfly tattoo is a symbol of change and of achieving your goals.

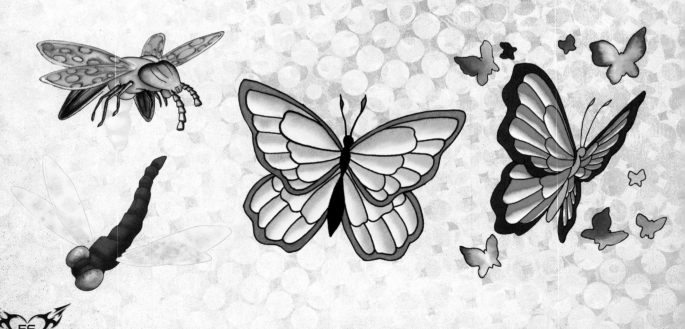

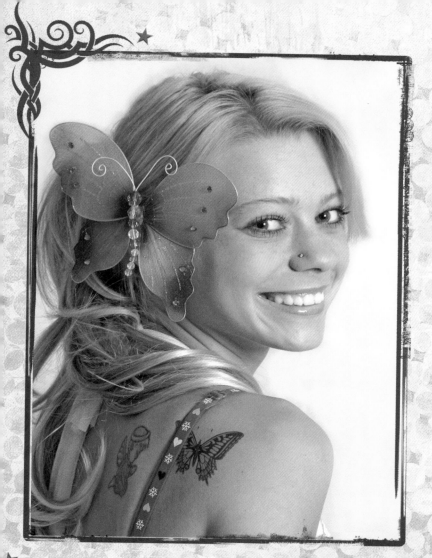

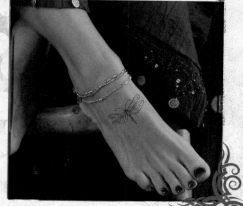

DRAGONFLY SPIRIT GUIDE

In Native American teachings the dragonfly is a spirit guide for people of all ages. For both men and women it represents change and wisdom, and it can also supposedly guide you and help you turn your wishes into a reality. A dragonfly tattoo can just be a pretty winged insect, but it can also hold a much deeper meaning if you look more closely!

Bees, Ladybugs & Spiders

Often seen as something to be avoided in real life, bees, wasps, and hornets are also very popular tattoo designs. Early beliefs claimed bees in particular represented the soul and stood for sexuality and chastity, as well as fertility and care. Killing a bee was even believed to bring bad luck, with Christians holding it as a symbol for hope. These days the hardworking bee can represent diligence, and also a respect for social order (or just a love of honey, if you like).

Ladybugs are seen as lucky insects, so as tattoos it makes sense that they're symbols of good luck. However, depending on where you live there is an added meaning: in England and France, the ladybug symbolizes good weather (usually because that's when they pop up); whereas in Sweden the ladybug is associated with finding your one true love.

In classic folklore ladybugs, like many insects, are surrounded with superstitions. For example, it's believed that if a ladybug lands on a married woman's hand, the number of spots on the ladybug's back will correspond with the number of children she'll have. Also, it's said that if someone catches a ladybug, they should make a wish and the ladybug will make it come true (make sure you let it go first).

Despite their presence in today's horror movies, in ancient times spiders were seen as a source of feminine power. Native American storytellers speak of a Spider Woman who existed at the dawn of creation and is a symbol of fertility, balance, and harmony. In ancient Greek mythology there is the tale of Arachne, who was so brilliant a weaver that the goddess Athena became jealous and made her life so miserable that the maiden died. Athena's remorse was so great that she made Arachne into a spider, so she could spin beautiful webs for all time. These days spiders symbolize creativity and hard work as well as femininity.

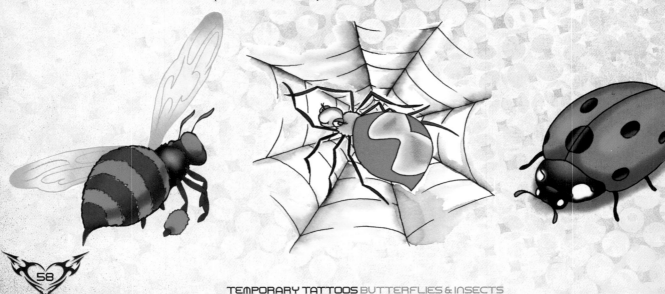

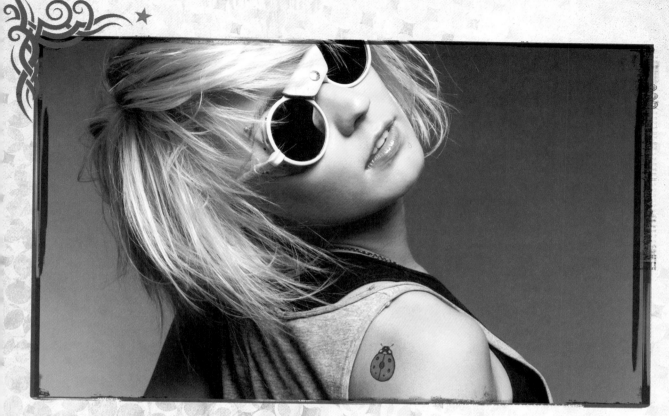

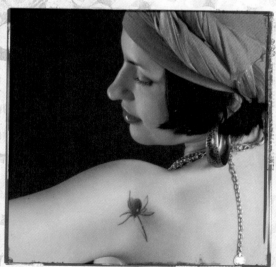

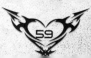

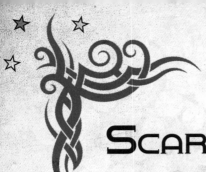

Scarabs & Scorpions

The most famous Ancient Egyptian insect is the Scarab Beetle—a sacred emblem that was usually worn as an amulet by ancient Egyptians. Its aim was to protect the wearer against evil and it was as important to the Egyptians as the cross is to Christians.

The Egyptians believed that Scarabs were associated with the god Khepri. It was Khepri that pushed the sun across the sky, just like a Scarab beetle would roll a ball of dung. As a result the scarab beetle became associated with the sun and ideas of rebirth or renewal: each day the sun disappeared, always to roll around and rise again the following day. Scarabs were even used when the Egyptians mummified a body—they would remove the heart and put a stone carved like a scarab beetle in its place, again as a symbol of rebirth.

Another armored insect, the scorpion, is often depicted as an image of death and danger. However, you can find the scorpion tattoo across all countries and cultures, usually as a powerful talisman that's meant to protect the bearer of the tattoo and ward off evil spirits. Scorpions can even have links with healing—amongst the ancient Mayans and in parts of Africa, the oil from the Scorpion's venom has been traditionally used as a medicine.

There's no escaping the scorpion's ferocious-looking appearance, though, and its natural defense mechanisms of pincers and a poisonous stinger give it a strong symbolic meaning of protection and self preservation above all things.

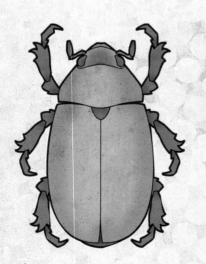

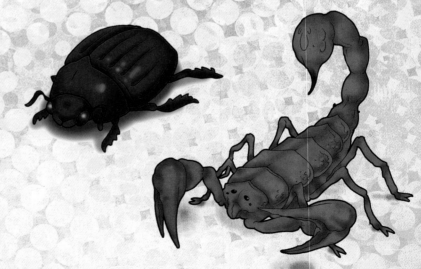

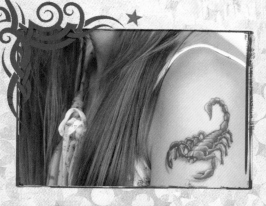

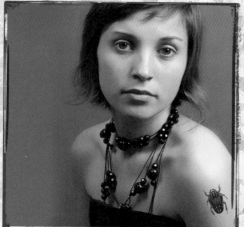

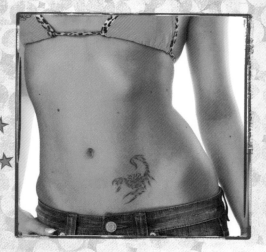

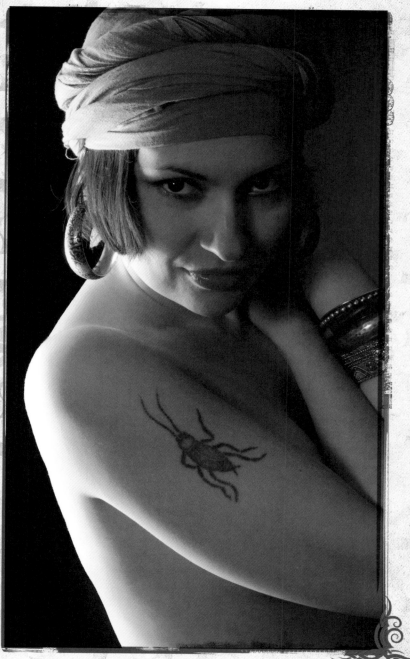

MYTHICAL CREATURES

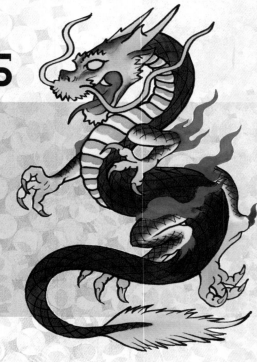

Tattoos of mythical creatures are extremely popular, mainly because they're such strong designs and represent important ideas such as loyalty and courage, as well as magic and spirituality. Whether you're choosing a unicorn, a mermaid, or a lesser-known mythical creature, research your topic well: different types of dragon hold different meanings, for example, so make sure you choose the right design. (There's nothing more embarrassing than turning up to a party wearing the wrong kind of dragon.)

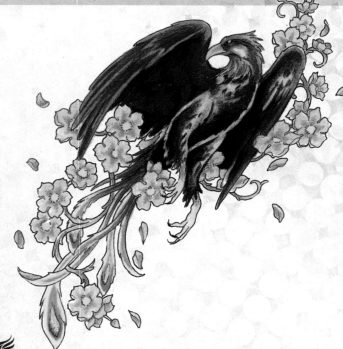

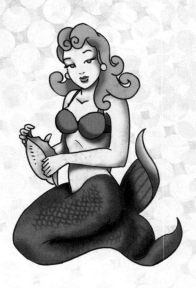

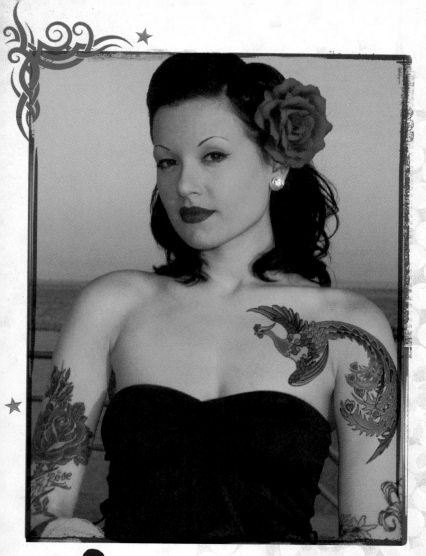

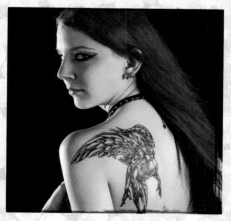

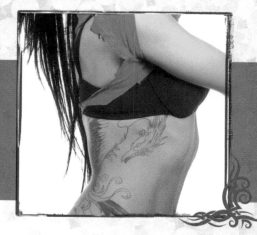

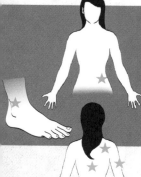

PLACEMENT

Mythical creatures can be worn in different places depending on what they are, but they are usually pretty substantial tattoos and so need a bigger area of skin than smaller tattoos. These are perfect for the back, shoulder, arm, or hip.

Dragons & Phoenix

Dragons are one of the most popular tattoo designs for both men and women. Their design is heavily influenced by Chinese and Japanese culture, where the dragon is an auspicious and lucky creature perceived as powerful, protective, and fearsome. In the West the depiction of the dragon is very different—it's often portrayed as evil and malicious, usually due to fairy tales, folklore, and religious stories of Saints slaying wicked dragons.

The Eastern dragon is a particularly powerful symbol, as it was originally found on the imperial robes of the Emperors and above temple doors signifying loyalty, transformation, and immortality. However, Eastern dragons can symbolize many other things, too: Oni, a Japanese dragon, was said to live in the skies and control the rain. Because rain is so important to rice cultivation, Oni was said to bring luck and good fortune.

The Phoenix (sometimes known as the firebird) is a mythological creature found in Greek, Roman, Far Eastern, and Chinese cultures. According to legend, the Phoenix is a bird that can live for 500 years. It cannot fall sick or get injured at any point in its lifetime but when the 500 years is over, it builds itself a funeral pyre, sets itself on fire and is reborn again three days later to live for another 500 years. As a result the phoenix is a lasting symbol of rebirth and new beginnings.

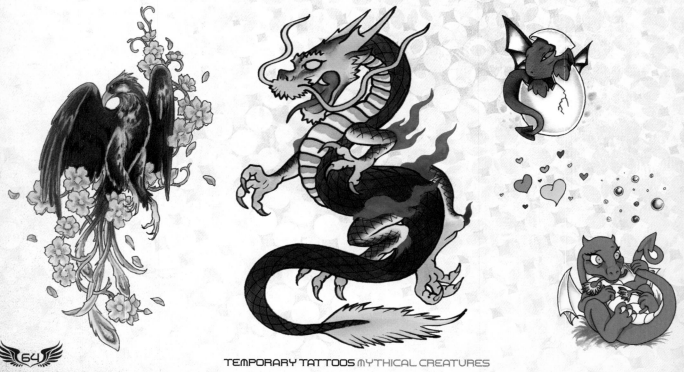

THE PHOENIX: BEYOND THE FLAMES

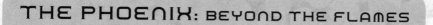

In Chinese mythology the Phoenix also represents the union of yin and yang and seen as the symbol of the Empress, so a Phoenix can also signify feminine qualities such as goodness and kindness as well as symbolizing immortality, resurrection, and life after death.

Unicorns & Pegasus

The Unicorn is a mystical white horse with a magical horn on its forehead which is believed to be a powerful antidote against poison. Unicorns are said to be highly intelligent and telepathic, with the ability to cure any illness; they're also famous for their virtue, courage, and strength.

Unicorns symbolize purity, elegance, and charm—partly due to legends stating that only a chaste maiden (i.e. a virgin) can attract one. In Chinese mythology, the Unicorn is a good omen that came to humans only as a sign of good times; the fact that no-one has seen a unicorn in living memory suggests that we are living in "bad" times. It's believed that unicorns will reappear when the time is right and when goodness reigns, thereby making them symbols of peace and utopia.

Pegasus is a constellation in the Northern sky, named after the winged white horse of Greek mythology. A symbol of the hero's journey to heaven, Pegasus sprang from the gorgon Medusa's body when her head was chopped off by the Greek hero, Perseus.

Without a mother, Pegasus roamed free and wild until he was caught with a golden bridle. However, when a man attempted to mount him, Pegasus threw him off and instead rose to the heavens, where he became a constellation.

Like all horse tattoos, a Pegasus design represents loyalty, endurance, speed, and bravery, as well as freedom and soaring inspiration.

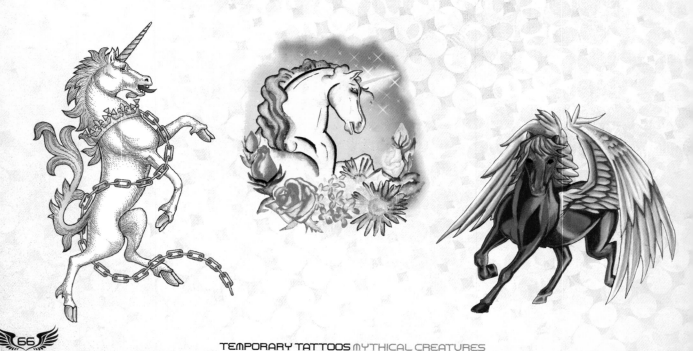

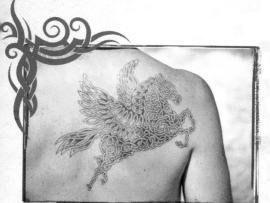

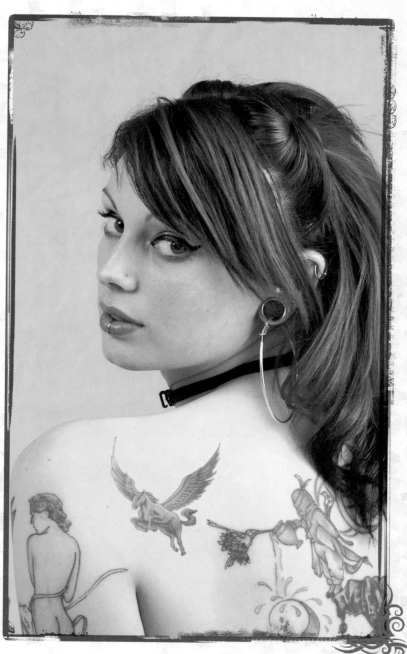

Mermaids

In traditional folklore a mermaid is an aquatic creature with a beautiful female human head and torso, and the tail of a fish. Found in many different cultures, mermaids are often depicted as water sprites attempting to lure human men to their underwater world.

Mermaid stories can be traced back to various ancient societies that lived close to the ocean. For example, the ancient Greeks and Romans have many stories about mermaids and other sea sirens. The Greeks believed that these half-women-half-sea-creatures would wait on the

rocks, combing their long flowing hair and trying to capture wayward sailors with their beautiful song. Sailors wear mermaid tattoos as a warning against temptation and a reminder of the perils of the sea, or combine them with anchors and other nautical themes to form a protective talisman.

These days mermaids are seen as potent symbols of female energy, with their long flowing hair and otherworldly beauty symbolizing love, fertility, and eroticism—so it's hardly surprising that they're as popular with women as they are with men.

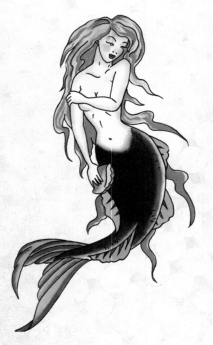

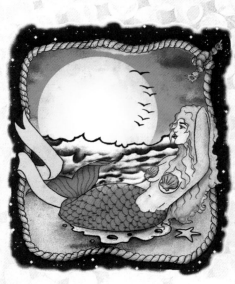

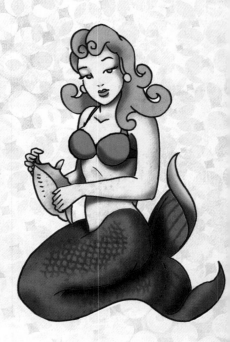

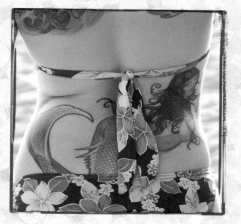

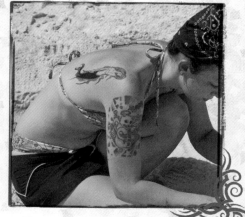

WHAT'S MY MERMAID?

There are many different representations of mermaids to choose from, ranging from a traditional siren-like image, a 1940s pinup-girl style design, or even a cartoon in line with Disney's image of mermaids. See which one calls to you!

ANIMALS

irls might choose an animal tattoo for any number of reasons, from a simple love of the animal in question, to a desire to embody the traditional qualities of that animal—a lion's courage, for example, or a cat's elegance. They might also choose a design for its mystical, spiritual, or even religious significance; many animal tattoos can symbolize things like strength, power, rebirth, or luck. An animal tattoo can be straightforward or it can let the wearer hint at hidden depths, which is why they're such a popular choice.

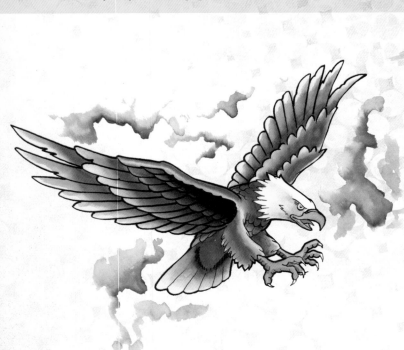

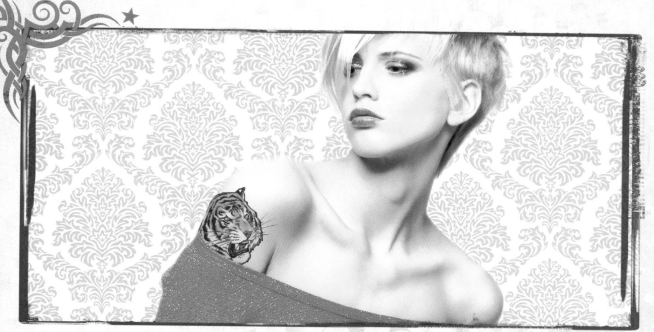

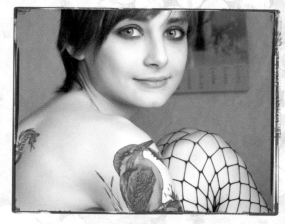

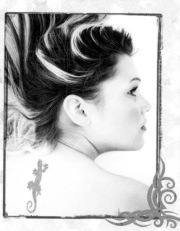

PLACEMENT

There are so many different kinds of animal tattoos, and depending on the design and subject, they can go pretty much anywhere on your body. Snakes look great on the calf, and delicate geckos and small birds are well suited to wrists and ankles. Dolphin tattoos are often found in pairs on the shoulder blade or abdomen, and big cat designs have a big impact on the upper back. But choose your design carefully and place it wherever it makes the most sense to you.

Koi Carp, Dolphins & Seahorses

Koi are a species of carp native to China, Japan, and Korea. Specially bred to have wild, brilliant colors, they are traditionally considered to be lucky, which is why they tend to be very popular tattoo designs. In Japan the Koi also stands for passionate love, and how you have your tattoo drawn affects its meaning: for example, if the tattoo is of a fish swimming upstream it represents courageous triumph over adversity. In China the Koi is considered the king of fish and legend has it that a leaping koi would transform into a dragon at Dragon Gate on China's Yellow River, which is why it's also a symbol for high hopes and dreams.

Dolphins are usually seen as highly intelligent creatures and are closely linked to new age ideology. As a result they represent change, wisdom, balance, harmony, freedom, trust, and understanding. Dolphins are also regarded as symbols of kindness, energy, prosperity, and the abundance of the Earth, as well as simply being quite beautiful.

Dolphins also held symbolic meanings for many ancient cultures. The ancient Greeks and Romans saw them as guardian spirits who would guide sailors safely to port; according to Celtic beliefs, they were associated with the healing powers of water and were symbols of both prosperity and guidance; and some Australian aboriginal tribes even claim to be directly descended from dolphins.

An elusive ocean-dweller, the seahorse, is a very popular tattoo choice that represents good luck and mystery. The Ancient Greeks and Romans believed the seahorse was an attribute of the sea god Poseidon/Neptune and as such it was considered a symbol of strength and power. The Europeans believed that the seahorse carried the souls of deceased sailors to the underworld—giving them safe passage and protection until they met their destination—while in Chinese cultures, the seahorse was revered as a type of sea dragon, thought to be powerful creatures and symbols of good luck.

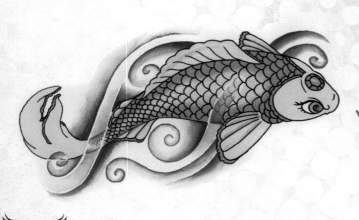

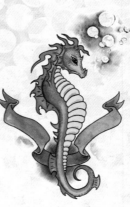

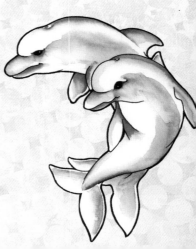

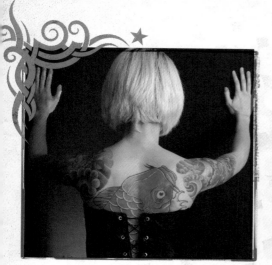

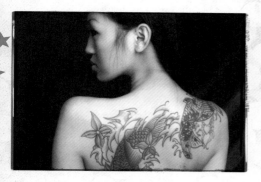
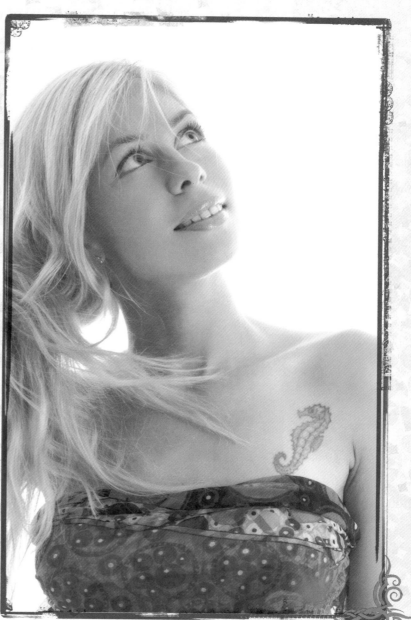

Eagles, Doves & Snakes

The Eagle represents spiritual protection and brings courage, wisdom, and knowledge. In most cultures it's felt the eagle has an ability to see hidden truths, rising above the material to see the spiritual, which is why it's often connected to spirit guides and teachers.

Some ancient cultures believed the eagle had a special connection with the sun, possibly because it could soar so much higher than man and be closer to it; as a result the eagle came to represent freedom, and the power to fly higher than anyone else. The eagle has also been associated with various gods in the Mayan, Greek, and Roman cultures but the symbolism behind the majority of eagle tattoos is the same—freedom, strength, and power.

A dove is a traditional Christian and Jewish symbol of love and peace. They're also used to represent the Holy Spirit, the third component of the Christian trinity. As such, the dove makes an appearance throughout the Bible—most memorably bringing a twig to Noah and signifying an end to the great flood. The Celts and other ancient peoples believed doves (as well as other birds) were omens of good or evil about to happen, and the Japanese interpreted the dove as a messenger from the God of War, carrying a sword to announce the end of a battle. From a non-religious point of view the dove is also a symbol of peace and hope for the future, which is why doves are released at weddings (religious and non-religious) and why dove tattoos can represent the bonds of matrimony.

The snake's phallic shape has long made it a symbol of fertility, but it's also a symbol of wisdom and knowledge. In Greek mythology, the serpent was associated with the goddess of the moon, a female symbol bringing knowledge to mankind; in India, snake cults worshipped them as goddesses of fertility and prophecy. Right across the world snakes are felt to be sacred and mystical animals, their ability to shed their skin associating them with ideas of rebirth and immortality.

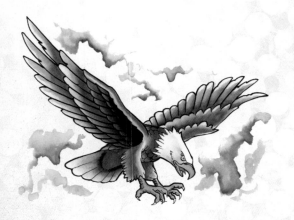

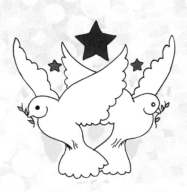

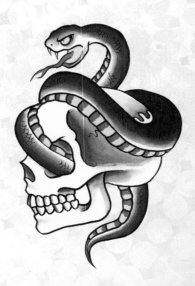

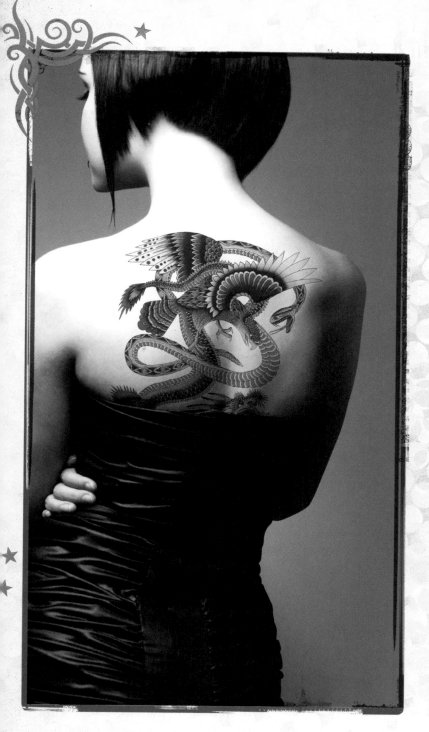

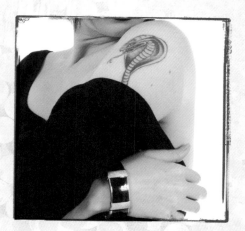

Cats & Tigers

Cat tattoos are amongst the most popular of all animal tattoos and the symbolism attached to them goes right back to the ancient Egyptians. Traditionally in Egypt cats were worshipped to the extent that anyone who killed one was sentenced to death! (Deceased cats were mummified and buried in special graveyards.) To the ancients, cats symbolized both the sun (they were considered to be daughters of Ra, the sun god) and the moon (because of the shape of their eyes).

Thanks to their graceful, aloof, and nocturnal nature, cats are associated with the night, and with mystery. This behaviour probably gave rise to the belief that cats are somehow magical, and why they became the animal most commonly associated with witches. The black cat, in particular, is the symbol of witchcraft and evil: in Norse mythology a black cat crossing your path means bad luck.

Of course, cats don't mean the same thing to all people. A black cat is viewed as a good omen in places like England and Japan, where it's seen as a symbol of luck, not evil. (Unless you're a mouse.)

Unlike their smaller cousins, much of the symbolism surrounding Tigers is to do with their physical strength and power. There are other meanings to tattoos of this big cat, though: they can represent a person's driving force, or they can symbolize femininity, anger, vengeance, and cunning.

Asian cultures have different symbolism and mythologies attached to tigers. For Koreans they are the king of the animals; the Chinese on the other hand see tigers as an earth symbol, rivalling the dragon in terms of power and strength, and their image is used to ward off evil.

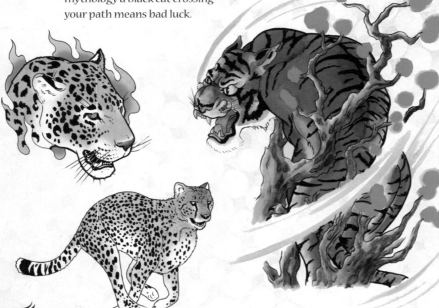

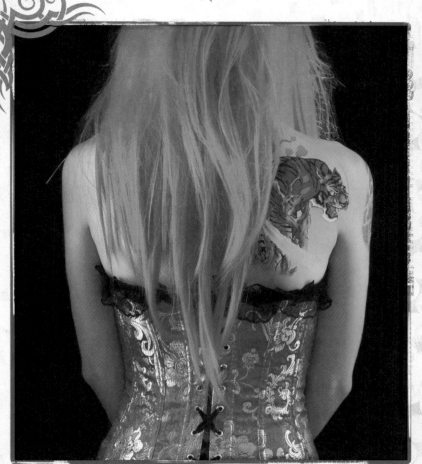

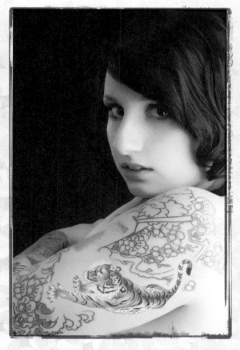

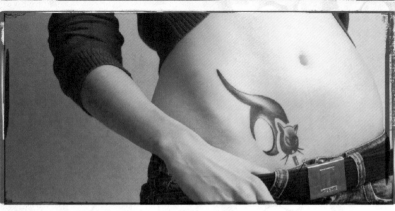

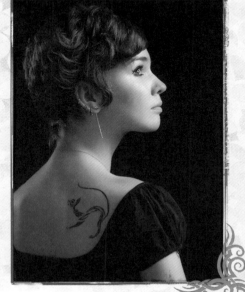

TOUGH·GIRL

One of the most important considerations when planning a tattoo is choosing a design that suits your own style and personality. While some girls prefer soft, pretty designs, they're just not right for others—they might go for tougher tattoos instead, choosing images that were traditionally the domain of men. Tough-girl tattoos use old school, traditional and rockabilly designs, as well as more provocative images like skulls, devils, and even barbed wire. Though hard-hitting and strong, these tattoos don't necessarily portray the darker side of life; a tattoo can be as much about your sense of humor as anything else!

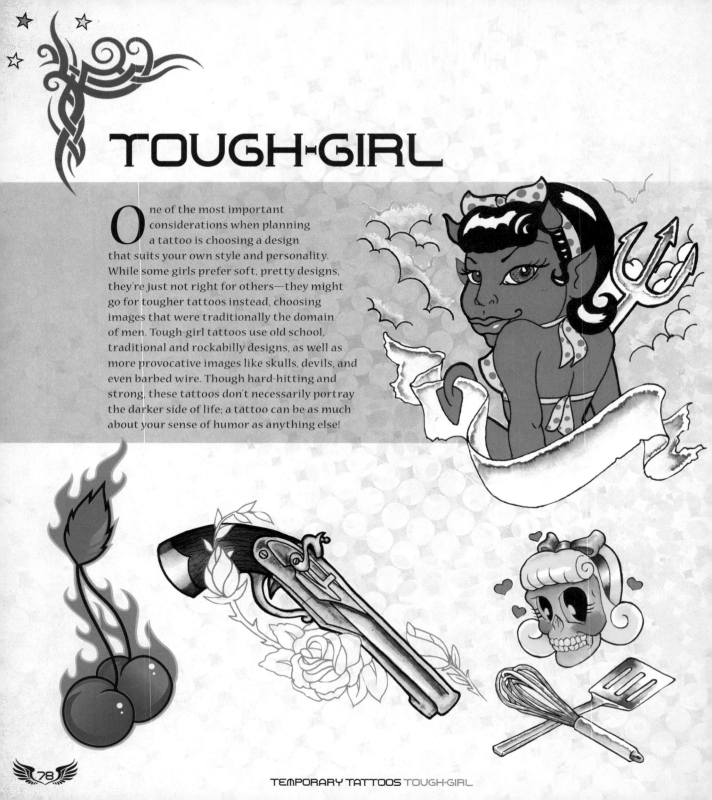

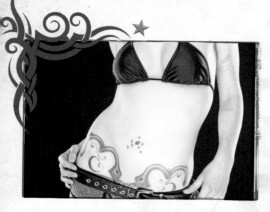

PLACEMENT

Tough-girl tattoos tend to be worn on the arms, shoulders and chest. Images like zombies sometimes worn on the forearms, with devils and barbed wire often being found on the upper arms. Sexy cherries suit the breast, lower abdomen, or the small of the back. You decide! Larger skulls can go across the back or chest, and a pair of pistols are great on the pelvis, pointing down...

Skulls, Devils & Zombies

Skull tattoos have a variety of meanings. Some skulls are just meant to be frightening, but others can be protective talismans driving away death and danger by looking it in the eye; they can equally represent mortality and remind us that life is short. Skulls were also ancient symbols indicating triumph over the enemy, and served as a warning to others to beware.

Despite their dark and evil image, devil tattoos tend to represent the mischievous and naughty devil inside us all rather than outright Devil worship. They're a sign that the wearer is both evil and good at the same time, and that what you see on the outside doesn't actually represent what's on the inside.

Devil tattoos can also hold a sexual meaning as devils can be a representation of desire and intense sexuality. Some girls counter this by going for a combination angel/devil tattoo that symbolizes the strength and purity of the angel while still giving off a "tough-girl" image.

More recent than skull or devil tattoos, horror and monster tattoos such as zombies, vampires, and skeletons are becoming increasingly popular. They look scary, and tap into our primal fears of death, the afterlife, and the unknown. The word zombie is derived from the Congo word "nzambi," which means "spirit of a dead person," but zombie (and vampire/monster) tattoos don't always need deeper meanings: they can simply showcase the imagination and creativity of the wearer and the tattoo artist.

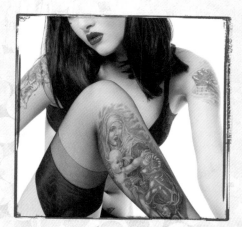

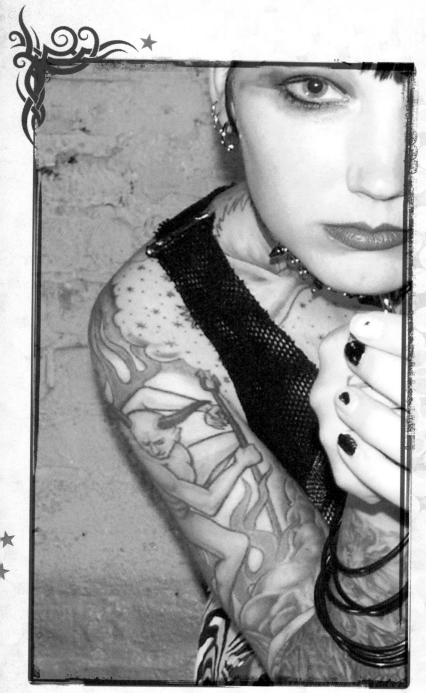

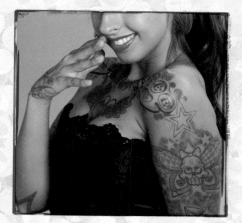

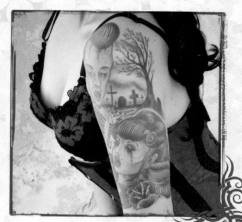

Barbed wire, Pistols & Knuckle tattoos

Barbed wire tattoos are hard and tough-looking, warning people to stay away, but they can also represent a strong inner self because barbed wire is often used to secure property, stopping animals (and people) getting in to or out of a certain area. Most girls choose a barbed wire tattoo for its association with strength, although some do choose it because of its links to the Wild West. Barbed wire tattoos are often done as bands around a limb, in shades of grey and black.

As well as links to the Wild West, pistols carry even stronger associations with strength and lethal power; in psychoanalysis the gun is also seen as the subconscious mind's way of expressing aggressive sexuality. This sexual connection is obvious in the placement of many pistol tattoos (positioned as if aimed towards the genitalia). Another popular location for dual pistols is on both hips; again, a look influenced by Wild West gunfighters.

Moving away from the prairies and onto the high seas, knuckle tattoos were originally used by sailors, who would spell out "Hold Fast" across their hands as a talisman to keep them from falling out of the rigging of a sailing ship. The idea was later taken up by prison inmates to show a personal struggle to overcome tough obstacles. Its placement also indicates strength, because getting your knuckles tattooed hurts! Knuckle tattoos can be very intimidating—get on the wrong side of someone wearing them and the design will literally be in your face.

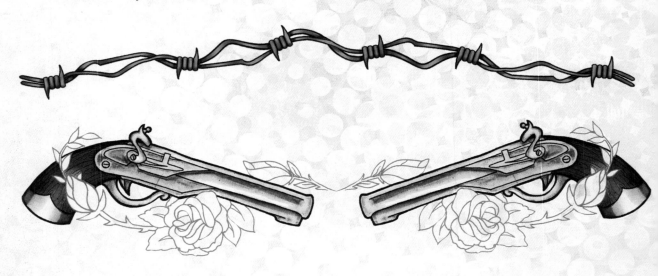

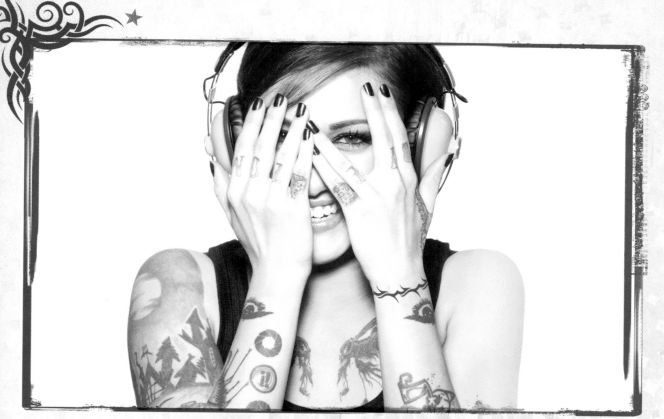

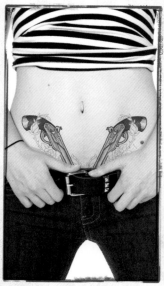

Cherries

Even though cherries are sweet, as a tattoo they can also ooze with sexuality—cherries are said to resemble a lover's lips, and "cherry" is a slang term for virginity. With their deep red, juicy connotations, cherry tattoos can represent fertility as well, making them sexually charged symbols that commonly appear on the hips, breasts, and around the groin.

There are other meanings, of course. Cherries appear on casino machines, so they can show that the wearer is a gambler. When designed in the bright, bold style associated with old school tattoos, cherry designs hint at a "naughty-but-nice" rebellious streak; they can also symbolize honesty and truthfulness, or sweetness and good fortune. And don't forget—cherries are also tasty and good for you, so some girls choose to get one to signify health and wellbeing. It's not all sex, sex, sex.

The color you choose can also be an important factor in the meaning of your tattoo. Deep, ripe cherry red symbolizes sexuality, whereas a pink cherry represents purity and innocence.

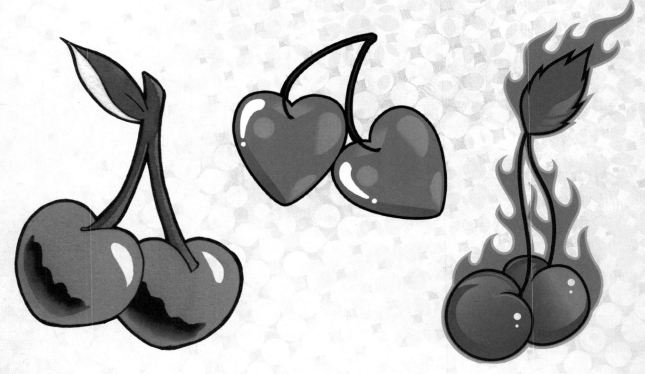

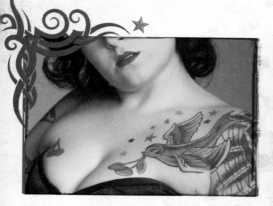

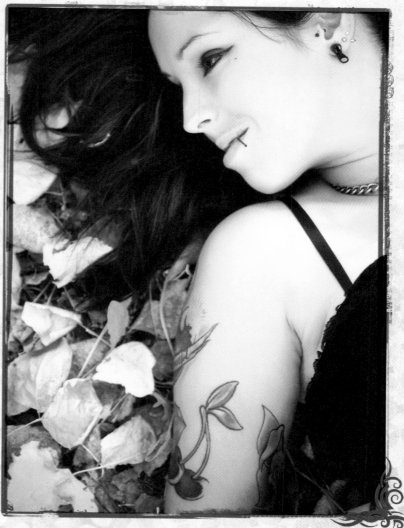

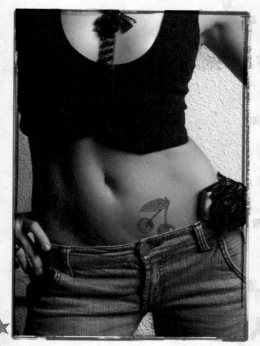

VERY CHERRY

There are many other variations on cherry designs, each carrying a slightly different meaning. Passion and love are the order of the day for red cherries, but a cherry with dewdrops on the stem signifies freshness and beauty. Flaming cherry tattoos symbolize burning desires, while cherry tattoos with whipped cream speak of sweetness.

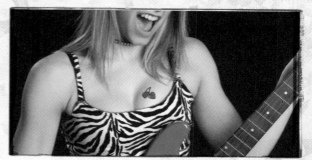

ZODIAC

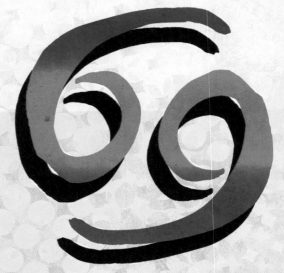

Zodiac symbols make great tattoos because they're simple, distinctive and come loaded with symbolism. Girls might choose them to show their belief in the art of astrology and horoscopes, or to express pride in the characteristics of their star sign. Zodiac tattoos can be simple symbols, such as line drawings of a fish for Pisces or scales for Libra, or more artistic interpretations like a strong and aggressive bull for Taurus or a virginal angel for Virgo. If you're interested in Zodiac tattoos be aware that this chapter only deals with the 12 signs of the Western (or "Greek") Zodiac—but that should be plenty to get you started...

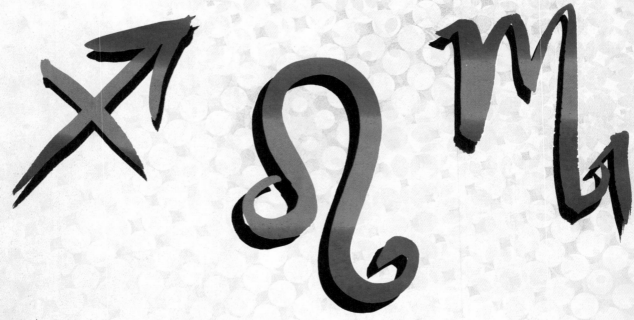

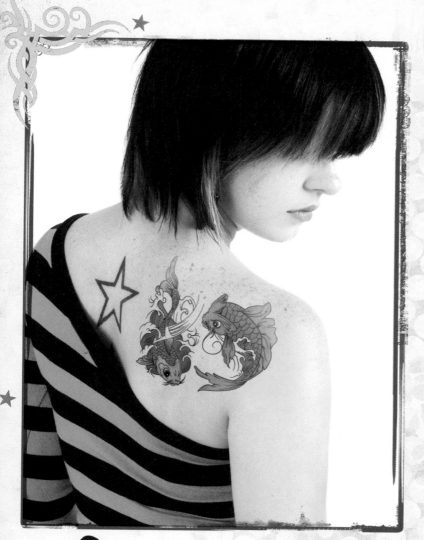

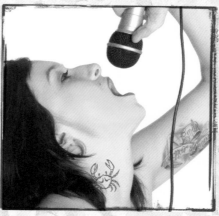

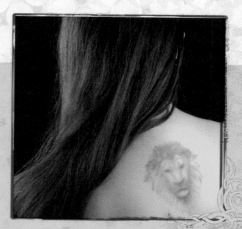

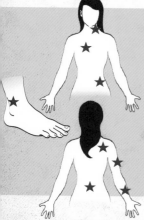

PLACEMENT

Some girls like to proudly display their zodiac tattoos on their wrists and forearms where they're easy to see; some might like their zodiac symbol on their biceps to make them feel stronger; others might want to keep their star sign more secret, and wear them on the lower abdomen, hips, or butt, where they can be easily covered up. Experiment with the temporary tattoos, and see what feels right!

ARIES ~ March 21-April 20

Aries is a fire element sign. Depicted as a ram, the Arien personality is strong and impulsive, and for this reason Aries tattoos tend to be bold and inspirational. People born under the sign are courageous and adventurous and live for the thrill of the chase; any of these traits can be easily incorporated into a tattoo design, as can any of the characteristics listed below.

Characteristics associated with Aries:
· Color: Red
· Flower: Buttercup
· Gem: Diamond/
Aquamarine

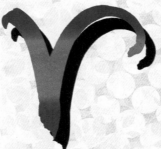

TAURUS ~ April 21-May 20

Taurus, an earth sign, is depicted as a bull. Taureans can be steady and beautiful, warm, sincere, sensual, and loyal, which is why tattoos for this sign are bold and strong but also more down to earth than other signs. As Venus is concerned with love and personal relationships (as well as the arts and fashion) tattoos for this sign can be fairly imaginative.

Characteristics associated with Taurus:
· Color: Red-Orange
· Flower: Daisy
· Gem: Amethyst

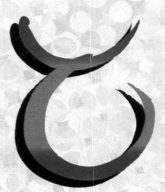

GEMINI ~ May 21-June 20

Gemini is an air sign, depicted by twins. Tattoos representing Gemini tend to be fun-loving, idealistic, and youthful, as in many ways a Gemini is an eternal child: bright, alert, curious, and always eager for new experiences (but also a little bit troublesome).

Characteristics associated with Gemini:
· Color: Yellow
· Flower: Lily-of-the-Valley
· Gem: Agate

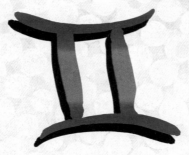

CANCER ~ June 21-July 22

The Cancerian crab is an emotional water sign and can be kind, loving, introverted, loyal, and sensitive. Cancer tattoos often embrace all these facets and might include sentimental images of things that are dear to the wearer, be they a person, a familiar place or a cherished possession.

Characteristics associated with Cancer:
· Color: Grey-green
· Flower: Moonflower
· Gem: Pearl

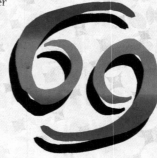

TEMPORARY TATTOOS ZODIAC

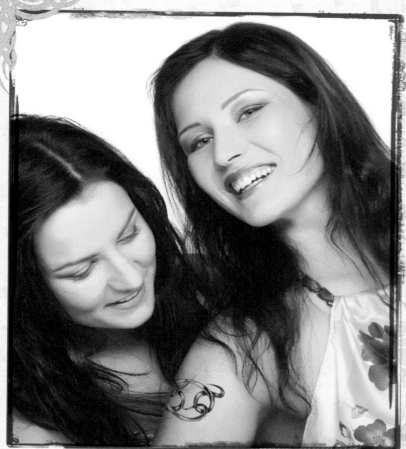

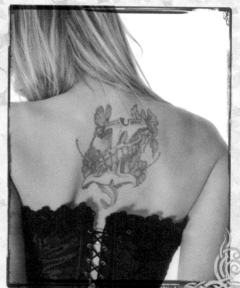

LEO ~ July 23–August 22

Leo is a proud fire sign and is depicted as a lion, with the symbol for Leo looking like an upside-down letter 'U' with curly tips. Some say it looks like the mane of a lion, while others claim it represents the shape of the heart. Leos are active, warm-hearted, positive, and theatrical; tattoos tend to reflect this, some showing a lion with a beating heart, others showing a more imposing and fearsome beast..

Characteristics associated with Leo :

· Color: Yellow
· Flower: Marigold
· Gem: Ruby

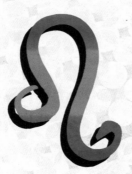

LIBRA ~ September 23–October 22

Libra is an air sign, represented by scales. The Libran personality believes in doing things right: just as scales have two sides, a Libra believes in balance e.g. working hard then relaxing. Tattoos tend to reflect this need for stability, with harmony and balance being the key elements.

Characteristics associated with Libra:

· Color: Green
· Flower: Violet
· Gem: Opal

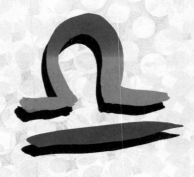

VIRGO ~ August 23–September 22

Virgo, an earth sign, is depicted as a virtuous maiden holding either flowers, ears of corn, or a sheaf of wheat. Occasionally she is depicted with wings and looking angelic as a sign of her spirituality. Virgos have a quiet dignity and often seek perfection, so tattoos tend to reflect this.

Characteristics associated with Virgo:

· Color: Dark blues
· Flower: Azalea
· Gem: Sapphire

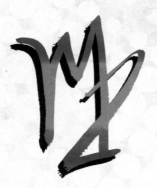

SCORPIO ~ October 23–November 21

Throughout history, water sign Scorpio has at times been depicted as both an eagle and a scorpion—it's the only one of the zodiac symbols to have two distinct animal images. Scorpios are strong and competitive, but also very intuitive; tattoos for this sign can be vivid and bold.

Characteristics associated with Scorpio:

· Color: Green-Blue
· Flower: Honeysuckle
· Gem: Topaz

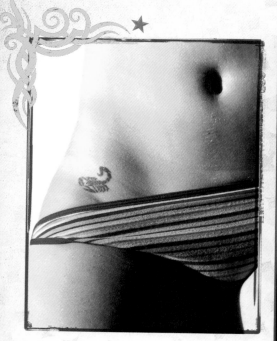

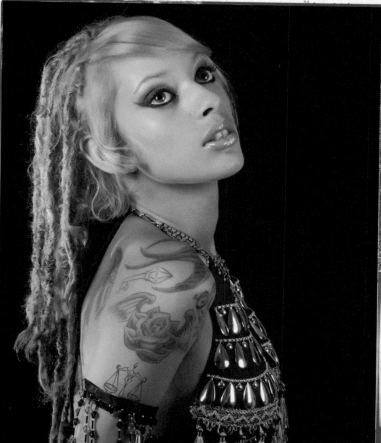

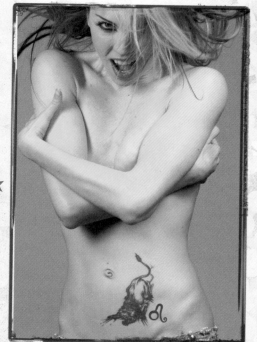

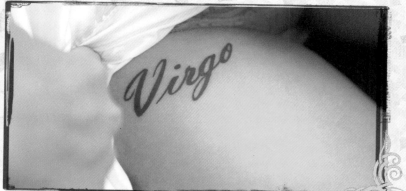

Virgo

SAGITTARIUS ~ Nov 22–Dec 21

Fire sign Sagittarius is the ninth sign in the zodiac, and is depicted as an archer. More specifically, the archer is a Centaur—an immortal creature (said to be a complete being) with the lower body of a horse and the torso of a man. Adventurers at heart, Sagittarians are independent souls and tattoos often reflect this.

Characteristics associated with Sagittarius:
· Color: Purple
· Flower: Goldenrod
· Gem: Turquoise

AQUARIUS ~ Jan 20–Feb 19

Aquarius is an air sign, and is the only one in the zodiac to feature a solitary man (all the other humans featured in the zodiac are twins or females). Aquarians generally have a "live and let live" attitude and love to inspire trust, impart knowledge, and help others; as a result Aquarius tattoos tend to be idealistic with an emotional edge.

Characteristics associated with Aquarius:
· Color: Blue–Violet
· Flower: Tulip
· Gem: Jade

CAPRICORN ~ Dec 22–Jan 19

Capricorn is an earth sign, often depicted as an animal with the upper body of a goat and the lower body of a sea-creature (something like a mermaid's tail). Serious, disciplined, and quietly ambitious, Capricorns are driven to prove themselves and to achieve material success. Tattoos depicting Capricorn are understated and simple, with many girls choosing a design that portrays the goatfish, or Sea-Goat.

Characteristics associated with Capricorn:
· Color: Deep Blue
· Flower: Poppy
· Gem: Garnet

PISCES ~ Feb 20–Mar 20

Water sign Pisces is the twelfth and final sign in the zodiac, depicted as two fish swimming around each other and connected by a band. A skilled mediator, Pisces is also a daydreamer and avoids getting "too much" reality, so tattoos tend to be theatrical or fantasy-like.

Characteristics associated with Pisces:
· Color: Violet
· Flower: Violet
· Gem: Moonstone

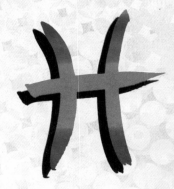

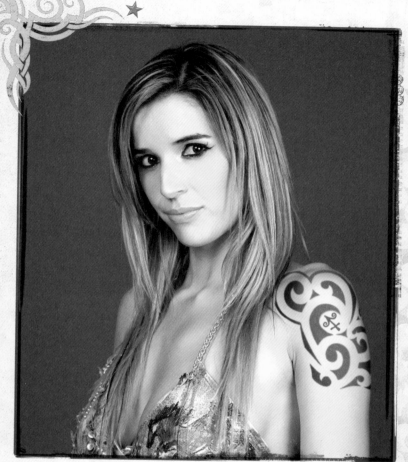

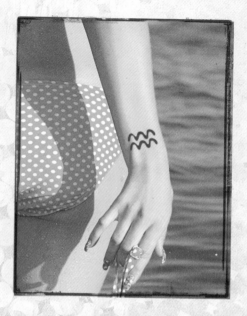

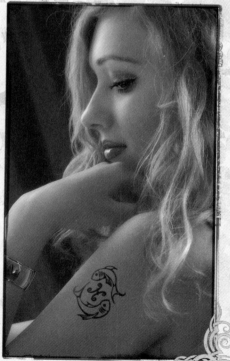

INDEX

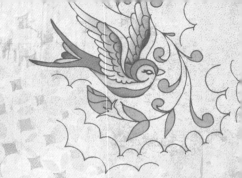

CREDITS

All images are the copyright of Quintet Publishing Limited. While every effort has been made to credit contributors, Quintet Publishing would like to apologize should there have been any omissions or errors—and would be pleased to make the appropriate correction for future editions of the book.

Alamy: 13 TL © Ross Aitken/Alamy; 31 CL © Miguel A. Munoz Pellicer/Alamy; 35 T © Richard Newton/Alamy; 35 CB © Paul Broadbent/Alamy

Corbis: 10 BL © Vincent Kessler/corbis; 11 TR © Alison Wright/corbis; 19 TR © Kristie Tweed/corbis; 25 R © corbis; 55 LC © Larry Williams/corbis

Fotolia: 9 LC © Sergei Tankov; 45 L © Photocharts; 45 CR © Radu Fizesan; 49 TR © Vetea Toomaru; 67 BL © Konstantin Minov; 69 TR © Karin Lau; 75 BR © Norman Pogson; 77 BL © Bilderquelle; 87 RC © Jason Stitt; 89 BR © Rebecca Abell

Getty: 15 TR © WIN-Initiative/Getty Images; 10 TL © Trinette Reed/Getty Images; 19 BR © Antenna/Getty Images; 21 CR © Holly Wilmeth/Getty Images; 21 BR © Gale Zucker/Getty Images; 31 BL © Denis Felix/Getty Images; 57 RC © Rebecca Drobis/Getty Images; 67 TL © Andrew Holt/Getty Images; 87 TR © Alberto Incrocci/Getty Images

iStock: 9 BL © 17 BC © Karolina Paszkiewicz; 19 CL © Nick Free; 21 L © Simon Gurney; 25 TL © Branislav Ostojic; 25 CL © Eduardo Jose Bernardino; 27 L © Marc Fischer; 29 BL © Lev Dolgatshjov; 29 BC; 30 BL & 32 BC © Song Speckels; 32 BL © Andrea Hill; 32 BR © Rebecca Lowe; 33 BR © Miklos Voros; 35 BL © Simon Podgorsek; 39 L © Justin Horrocks; 43 TL © Heidi Anglesey; 51 TR © Maciej Laska; 53 CR © Claudia Dewald; 55 TL © Ozren Majeric; 55 BL © Chris Cramly; 55 R © Leah Marshall; 57 TR © Cliff Parnell; 63 L; 63 RC © Simon Podgorsek; 65 BR; 67 LC © Heidi Kristensen; 67 R © Mark Hayes; 71 L © Jeffrey Shanes; 73 TL © Eva Serrabassa; 73 BL; 83 T © Chris Cramly; 87 BR; 91 BR © Andre Maslennikov

Independent: 23 CL, 39 TR © Shelley Knowles-Dixon

Mary Evans: 10 CL © Mary Evans Picture Library 2008

Shutterstock: 4 TR © Ferin; 4 CR © BooHoo; 4 BC © John Lock; 5 TL © BooHoo; 5 TR © Christos Georghiou; 5 CL © Ferin; 5, 8 BL, 38 BR, 39 BL © Bertold Werkmann; 5 BR © ksysha; 9 L © Gordan; 9 TL © Tatiana Morozova; 9 LC © Scott Kapich; 10 CR © ChipPix; 11 CL © Marin; 11 BL © Ronald Sumners; 11 BR © Polina Lobanova; 12 TR © John Lock; 12 BL © Alexey Stiop; 12 BR © jon le-bon; 13 BR © iofoto; 15 L © Buida Nikita Yourievich; 15 CR © 101images; 15 BR © foto.fritz; 17 T © Xsandra; 17 BR © Andrew Taylor; 17 BR © Camilo Torres; 21 TR © Steven Paine; 23 T © Jeff Banke; 23 C © Brian Chase; 23 CR © DNF-Style Photography; 25 BL © Konrad Bak; 27 TR © Christo; 27 CR © Dianna Rae; 27 BR © Terekhov Igor; 29 T © George Anchev; 29 BR © Mehmet Dilsiz; 31 TL © Szefei; 31 R © R.Filip; 33 L © Jason Stitt; 33 TR © iofoto; 33 CR © iofoto; 35 BL; 37 TL © Mayer George Vladimirovich; 37 CL © Zoom Team; 37 BL © Dukibu; 37 R © Phase4Photography; 39 CR © Senai Aksoy; 39 BR © William Casey; 41 T © Roxana Gonzalez; 41 BL © Ted Denson; 41 BC © Kelly Boreson; 41 BR © ostill; 42 BC © Charlotte Erpenbeck; 43 LC © Steven Paine; 43 BL © Tatiana Morozova; 43 R © DNF-Style Photography; 45 TR © BrianSM; 45 BR © Carlo Dapino; 46 BL, 48 C © Willierossin; 47 T © Rene Jansa; 47 BL © Jose AS Reyes; 47 BC © Adam Radosavljevic; 47 BR © Vasily Koval; 49 L © Pavel Sazonov; 49 RC © Angela Hawkey; 48 BR © Bairachnyi Dmitry; 51 L © Peter Weber; 51 RC © Ronald Sumners; 51 BR © Suravid; 53 T © Jose AS Reyes; 53 CL © Sergey Sukhorukov; 53 BR © Maryloo; 57 L © Glenn Gaffney; 57 BR © Kevin Riggs; 59 T © Konstantynov; 59 BL © Ronald Sumners; 59 BC © Maryloo; 59 BR © Peter Kim; 60 TL © Bartosz Ostrowski; 61 LC © Rul Vale de Sousa; 61 LB © BESTWEB; 61 R © Maryloo; 63 TR © Michael Drager; 65 T © Nicole Weiss; 65 L © Valua Vitaly; 65 C © Phase4Photography; 66 BL © Olga Rutko; 69 L © CREATISTA; 69 RC © iofoto; 69 BR © David Ross; 71 T © Ivan Mladenov; 71 LC © Elena Rostunova; 71 R © Doug Stevens; 73 LC © Andresr; 73 R © Lev Dolgachov; 75 L © Mayer George Vladimirovich; 75 TR © Julia Lutgendorf; 75 RC © 76 BR © Ferin; 77 TL © Elisanth; 77 TR © Shredboy Studios; 77 BR © Oshvinstev Alexander; 79 TL © 1759443 Ontario Incorporated; 79 LC © Olga Ekaterincheva; 79 BL © Ronald Sumners; 79 R © Mary Ann Madsen; 81 L © Cora Reed; 81 TR © Olga Ekaterincheva; 81 RC © Rebecca Abell; 81 BR © Karin Hildebrand Lau; 83 BL © Sparkling Moments Photography; 83 BC © Charles Knox; 83 BR © Jason Stitt; 85 TL © Sophie Louise Asselin; 85 BL © Peter Kim; 85 TR © Jose AS Reyes; 85 BR © Jason Stitt; 87 TL © Shae Cardenas; 89 TL © Raisa Kanareva; 89 BL © Ekaterina Pokrovskaya; 89 TR © Bartosz Niedzwiecki; 91 TL © Eva Madrazo; 91 BL © Wallenrock; 91 TR © Imagesolutions; 93 TL © Rui Vale de Sousa; 93 BL © Lucian Coman; 93 TR © vnlit; 93 BR © Arapov Sergey